NAZARETH
SPEEDWAY

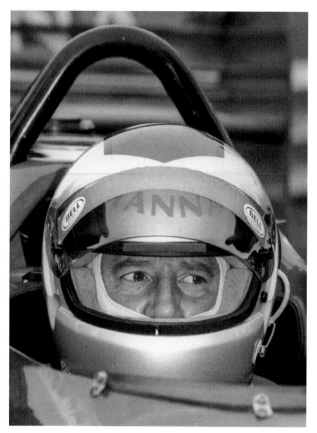

Mario Andretti, who went on to be one of the most successful drivers in auto racing history, put Nazareth on the map. He came to Nazareth from Italy and was surprised to find a racetrack. He and his brother Aldo started racing in 1959 on Nazareth's half-mile dirt track in a 1948 Hudson Hornet Sportsman. Mario then won 21 out of the 46 races in the 1960–1961 season. He went on to be the 1978 Formula One world champion, a four-time Indy Car champion, and the only driver to win the Indianapolis 500 (1969), the Daytona 500 (1967), and Formula One world championship. He is one of only two drivers to have raced in the NASCAR Sprint Cup Series, Formula One, and the Indianapolis 500. He still lives in Nazareth today. (Courtesy of Jack Kromer.)

FRONT COVER: Alan "Rags" Carter poses next to his No. 1 car at the half-mile dirt track. He is ranked second in wins at Nazareth, winning 45 races between 1964 and 1980. (Courtesy of Walter Howell.)

COVER BACKGROUND: Spectators fill the grandstands to watch an Indy Car race on the one-mile asphalt track during the summer of 2004. (Courtesy of Tracy L. Berger-Carmen.)

BACK COVER: The infield media center was the central hub for writers, photographers, and press representatives. It also stood next to the pit area, where drivers and crew members are seen here preparing for the last race at Nazareth, in August 2004. (Courtesy of Tracy L. Berger-Carmen.)

NAZARETH
SPEEDWAY

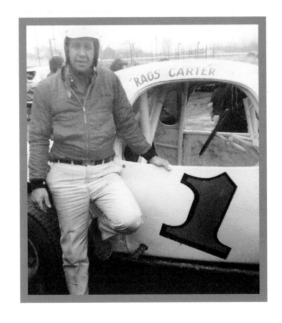

Tracy L. Berger-Carmen

ARCADIA
PUBLISHING

In loving memory of my father, Richard R. Berger Sr. He always had good stories to tell me about working on cars.

Published by Arcadia Publishing
Charleston, South Carolina

Printed in the United States of America

Library of Congress Control Number: 2013936573

For all general information, please contact Arcadia Publishing:
Telephone 843-853-2070
Fax 843-853-0044
E-mail sales@arcadiapublishing.com
For customer service and orders:
Toll-Free 1-888-313-2665

Visit us on the Internet at www.arcadiapublishing.com

CONTENTS

ACKNOWLEDGMENTS

I would like to thank the entire community that helped me put this together. It was a joint effort by many who shared the fun (and not-so-fun) times at the racetrack. Thank you to my Facebook friends who shared and continue to share their stories and also helped with identifying drivers, hometowns, or any other information that I could not find elsewhere.

Thanks to Jack Kromer, Walter Howell, Jack Leach, James Frey, George Maureka, Phil Levering, Joe Kunkel, Penny Faust, Jeff Berger, Mike Hirschman, Randy Smith, Don Lawson, and Bob Snyder for sharing their photographs and scrapbooks with me. The process of selecting the best images for this book was not easy.

A big thank you goes to Scott Peters from Scott Shots Racing Photographs for all the work he did to make this book awesome. He went above and beyond to get the photographs needed and also helped check for historical accuracy, since it became confusing at times with two different tracks going on with different promoters and owners.

Thank you to Darell Mengel, Nazareth historian, for giving me the very early history lesson on Nazareth, sharing photographs for the book, and answering questions.

I appreciated hearing stories from many people who enjoy racing as much as I do while getting information from the following: the Nazareth Public Library, Frank Kelly, Justin Petschauer, Steve Pados, Susan Dreydoppel and the Moravian Historical Society, Alan Carter Jr., Pam Faust, Brenda Pickell, Bobby Pickell Jr., Randy Smith, Zane Zeiner, Don Lawson, Dino Oberto, Lew Boyd, Eric Beers, Ace Lane, Buzzie Reutimann, and Ward and Dot Crozier.

Thank you to Chris Knight for helping me get started and helping me navigate through Photoshop (it has been a few years).

Thanks to my husband, Larry Carmen, and my mother, Diana Berger, who watched our son while I worked on the book. It was not easy working with a three-year-old in the house.

INTRODUCTION

Nazareth was established in 1740 by the Moravian Church. It was a small farming community with a lot of potential but only Moravians were allowed to live there. In 1855, the Northampton County Agricultural Fairgrounds were formed in the center of town. The horse racetrack was along Broad Street between East Park and South Streets. There were competitions in the main building, and horses were housed in separate buildings along the track. Horse racing started to become popular there in the 1890s. People continued to flock to Nazareth for jobs in the cement industry. The area's rich soil, full of Limestone and other compounds, made cement, and continues to do so today. About 10 years later, the fairgrounds were running out of space and needed more room. The fairgrounds were then moved to a 30-acre piece of land at Routes 191 and 248. A farmers' market was added right beside the track.

There were a few sulky races with horses on a half-mile dirt track in the early 1900s. Gambling, however, is what brought in the people. In the 1920s, a series of events were held at the track, including something that came out of Europe known as auto polo. Cars were used instead of horses, and drivers had mallets with which to hit a regulation-sized basketball into a goal at either end. It was a dangerous "sport" that produced many broken bones, not to mention mangled vehicles.

The fairgrounds held occasional events after that, but the Great Depression and the government cancellation of racing after the bombing of Pearl Harbor made it difficult to hold anything at the racetrack. In 1947, the American Automobile Association (AAA) brought in traveling racers, which proved to be popular. Once, they brought 35 cars and an estimated 11,000 spectators came out to see some auto racing. The population of Nazareth as of the 1940 census was only 5,721 people.

In 1952, Jerry Fried took over the Nazareth fairgrounds track and managed to make it into a major attraction for stock-car racing. Soon, the stands were getting filled from his marketing efforts and because of guaranteed purses for drivers.

George Rice "Joie" Chitwood started the Joie Chitwood Thrill Show, which was based out of Florida and amazed audiences with daredevil stunts and record-breaking two-wheel driving. There were 21 daredevil acts in the show, mostly involving motorcycles and Chevrolet Corvettes and Camaros. Chitwood, along with his two sons, Joie Jr. and Tim, joined other stuntmen and traveled the country for more than 40 years, visiting large and small towns, including Nazareth.

A yearly tradition at the Easter Sunday race was to let kids ride in a race car around the track. Kids would run down to the front stretch and pile into their favorite race car to go on a joy ride. There was only one extra seat in the cars, but the kids did not mind at all. Some drivers would make sure their own fans got a ride in their car. There were also Easter egg hunts on the infield.

Demolition derbies always drew a large crowd on the half-mile front stretch. People liked to see the destruction of cars colliding and hitting each other. In these competitions, parts would fly off, engines would stall, and radiators would erupt in nonstop action, twisting and mangling metal beyond repair. The winner was determined when there was only one car left running or moving. Usually, there were a few heats, with the best few in each heat going on to the feature to compete to be the overall winner. Today, most demolition derbies are held at county fairs and at a few local racetracks.

In April 1966, a five-turn, 1 1/8–mile track was added in addition to the old half-mile track. With only one race that year, Frankie Schneider walked away with the heat win, the feature win, and the fastest lap time, and went on to win many more. Nazareth National Speedway held a total of 52 races from 1966 to its closing in 1971.

After an 11-year hiatus, in 1982, Lindy Vicari took over and shortened the track to one mile. In December, the United States Auto Club (USAC) Silver Crown race was held, but it ended after only 54 laps because of darkness. Keith Kauffman of Mifflintown, Pennsylvania, took the checkered flag that year. A few more races were held there before the one-mile track closed in 1983. The half-mile track continued having weekly racing schedules until 1988.

Ward Crosier along with his wife, Dot, saw that there was a new type of racing that was popular on the West Coast that came over to the United States from Japan. They convinced Jerry Fried, promoter of the half-mile track, to take a chance and run an enduro race. They rented the track for $300, and car registrations poured in. The first race was an instant success. The next race, Fried charged the Crosiers $3,000 to rent the track. It was one of the first tracks to have and successfully run enduro racing in the late 1980s. Enduro races are entry-level stock-car racing where a driver would have to "endure" many laps. They are "common cars", the kind that are driven on the street. Like demolition derbies, drivers still had to take out the glass and flammable interior, but they were racing the car instead of intentionally hitting it. Big payouts with 200 to 300 cars on the track at once brought in people to the grandstands to watch and cheer on their favorite drivers. It is said that the Crosiers were the "Pioneers of Enduro Racing" in the Northeast. Soon after that, other tracks held enduro races but did not have nearly as many cars as Nazareth did. The last enduro race on dirt at Nazareth was 1988. Enduros are still popular today at many local racetracks where there are still payouts, points, and trophies awarded.

Former racer and racing team owner Roger Penske bought the one-mile track in 1986 and laid down a layer of asphalt over the dirt. He opened the track a year later, naming it Pennsylvania International Raceway. It was the first racing oval with a warm-up lane from which to enter and exit the pit area. NASCAR, IRL, and CART series races were held at Nazareth's challenging asphalt track. Many of the races were on national television.

Although Vicaro and Penske tried hard to make the track work, it was forced to close in 2004. To this day, the track still belongs to the International Speedway Corporation (ISC), which had merged with Penske. There has been interest in the property, but it is unlikely that it will become a track again.

1

THE NAZARETH
FAIRGROUNDS

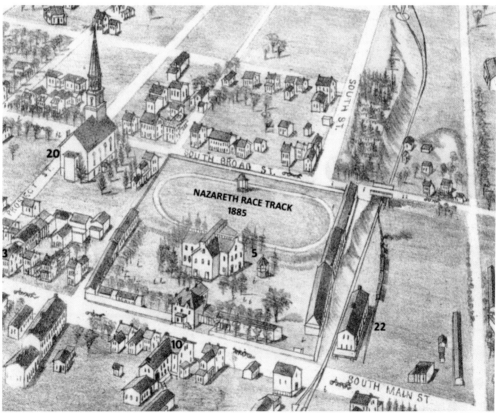

The Nazareth fairgrounds were at the center of town in the late 1880s. The track ran along Broad Street between East Park and South Streets to the Bangor & Portland Railway station. The exhibit building was in the middle of the track, with smaller buildings and stables for the horses along the perimeter. Nazareth Agricultural Works was across the street from the fair entrance, on Main Street. (Courtesy of Darrell Mengel.)

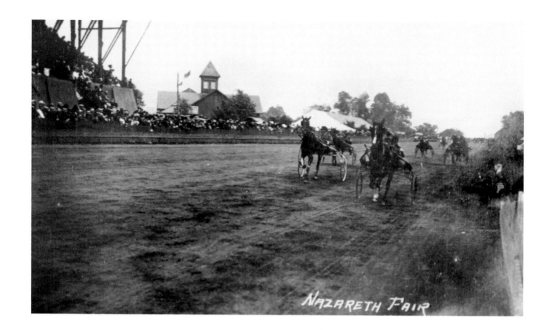

The Nazareth fairgrounds held sulky races (above and below), in which a driver sat in a two-wheeled cart and was pulled by a horse around the track. Regular horse races were also held on the track in the early 1900s. By then, it was already a half-mile track. A lot of special events also took place on the track, including circus acts that performed in front of the grandstands and Dick Rogers' All American Motor Maniacs, a thrill show in which stuntmen performed on top of moving cars, motorcycles went through fire, and cars crashed as they sped up ramps. (Both, courtesy of Darrell Mengel.)

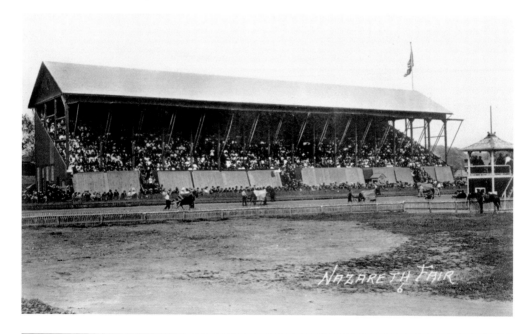

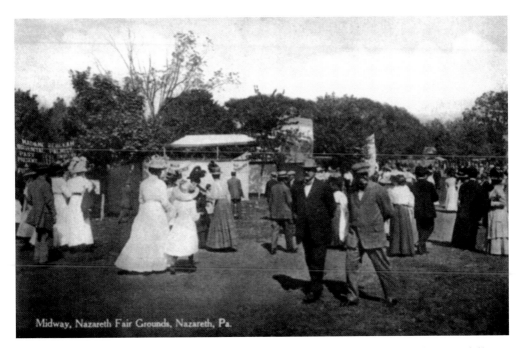

Midway, Nazareth Fair Grounds, Nazareth, Pa.

The midway at the fairgrounds (above), adjacent to the racetrack, featured many different types of vendors selling their wares and businesses advertising their products. One vendor was Madame Rebekah (left), a fortune-teller. The Dexter Portland Cement Company (below) had a display at the fair to advertise concrete farm products such as fences and lawn rollers, since a lot of attendees were farmers. The company later became Penn Dixie Cement Company and eventually went out of business. (Both, courtesy of Darrell Mengel.)

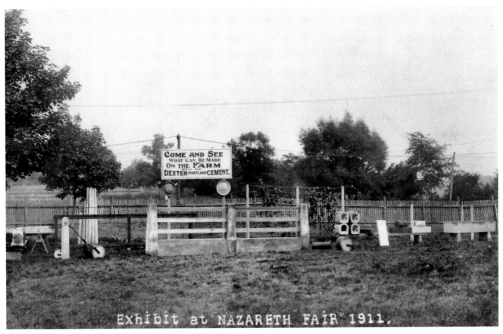

Exhibit at NAZARETH FAIR 1911.

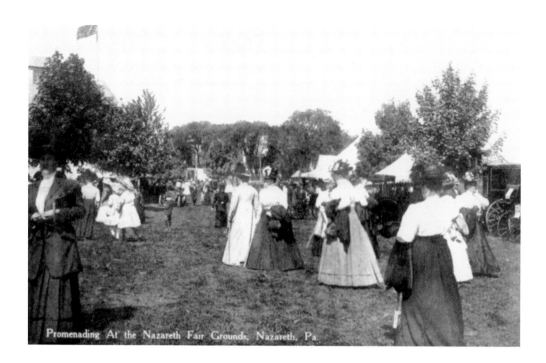

Promenading At the Nazareth Fair Grounds, Nazareth, Pa.

The promenade (above) was a popular area for ladies at the fairgrounds. The grandstands (below) were where the gentlemen congregated to see horse races or a thrill show. It was common for betting and wagering to take place in the grandstands during horse races. (Both, courtesy of Darrell Mengel.)

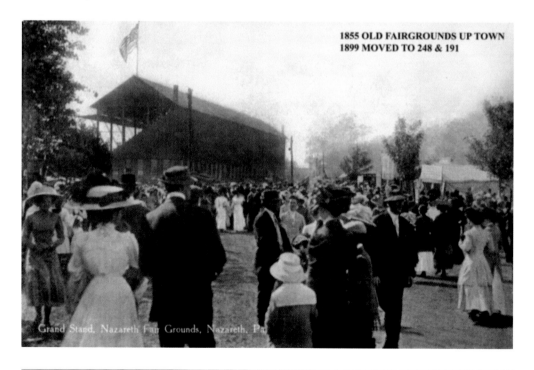

1855 OLD FAIRGROUNDS UP TOWN
1899 MOVED TO 248 & 191

Grand Stand, Nazareth Fair Grounds, Nazareth, Pa.

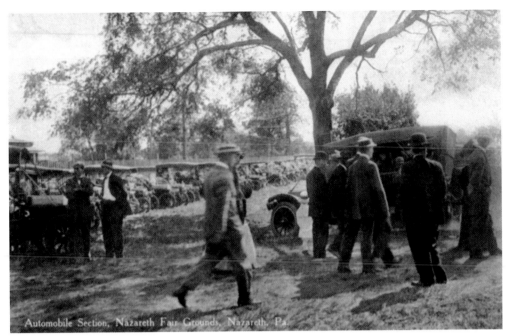

The parking area at the fairgrounds (above) was along the fence, although, in the early 1900s, few people had cars. Since the fair was at the edge of town, most attendees walked to the fair, while others took the train or trolley and walked a few blocks. Fair House No. 1 (below) was the main building at the fair. Inside were competitive exhibits, with entrants attempting to win categories such as the best five ears of corn and the best-tasting apple pie. These competitive exhibits offered participants ribbons—hopefully a blue one—and small cash awards. (Both, courtesy of Darrell Mengel.)

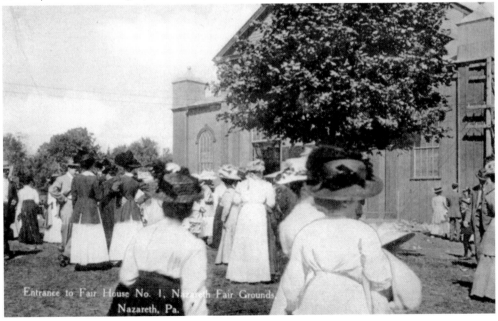

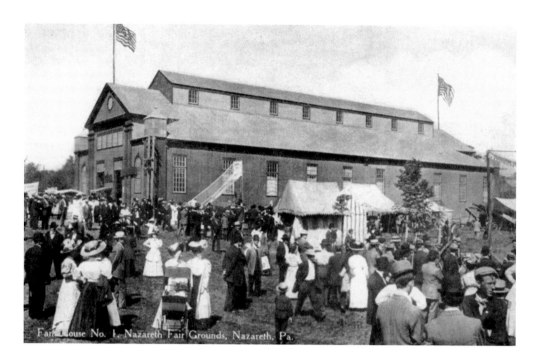

Fair House No. 1, Nazareth Fair Grounds, Nazareth, Pa.

Fair House No. 1 (above) was the most popular place at the fairgrounds to be. Around it were a lot of tents with games of chance and skill, such as throwing a basketball though a hoop to win a prize. The fair was a family event and admission was either free or very inexpensive, so parents could bring their children for a day of fun. Fair House No. 2 (below) was smaller than the main building but housed similar activities. (Both, courtesy of Darrell Mengel.)

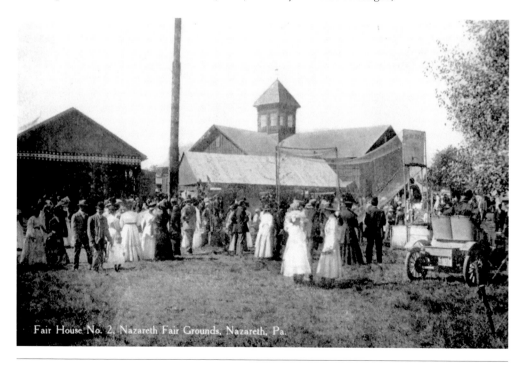

Fair House No. 2, Nazareth Fair Grounds, Nazareth, Pa.

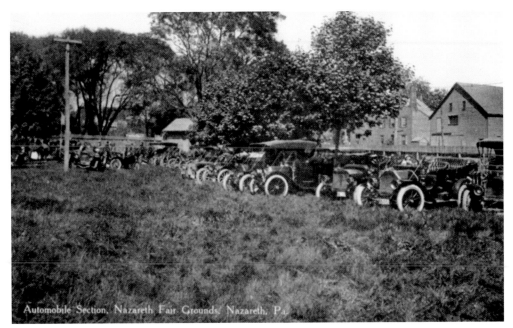

Automobile Section, Nazareth Fair Grounds, Nazareth, Pa.

A wide variety of vehicles were seen in the parking lot of the fairgrounds. Some were made for two, while others were made for four with a canopy. A few years later, some of these vehicles were also used for auto polo, a short-lived activity at the track because of how many injuries it caused and how many vehicles it destroyed. The entrance to the fairgrounds is seen below. The ticket window was to the left, as well as an ice-cream cart. In the background, through the trees, is the Kramer Knitting Mill's water tower and the railroad, with a coal car on it. To the right was a "bus" with multiple seats on it to transport a few people at a time. (Both, courtesy of Darrell Mengel.)

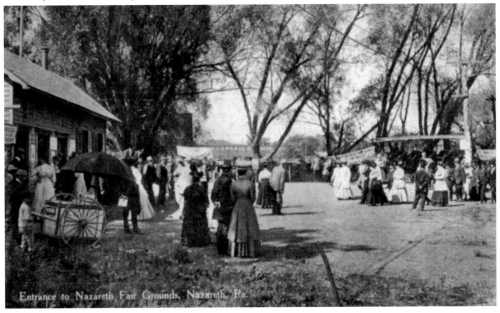

Entrance to Nazareth Fair Grounds, Nazareth, Pa.

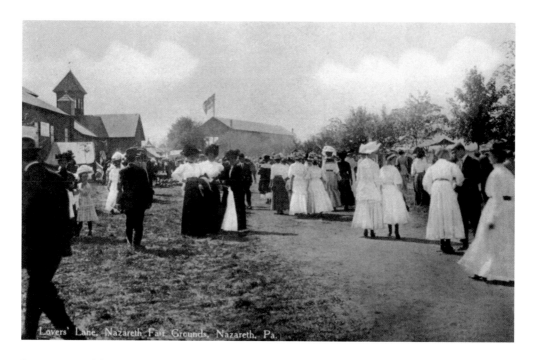

Lover's Lane (above) was a popular area at the fairgrounds for young men and women to meet and socialize on sunny afternoons. The view of the racetrack below shows how the Fair House buildings were situated on the property. There were many areas from which to watch the half-mile dirt track. Some spectators were brave enough to sit on the guardrail or near the fence around the track. (Both, courtesy of Darrell Mengel.)

THE NAZARETH FAIRGROUNDS

THE DIRT TRACK YEARS

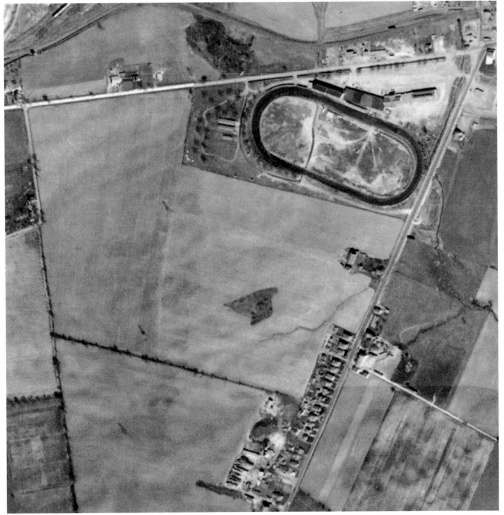

This 1955 aerial view shows how the half-mile track was configured and where the grandstands were situated on the Nazareth fairgrounds property. The track was very close to the intersection. Route 248 runs across the top of the image from east to west, while Route 191 is to the right going north to south. (Courtesy of Aerial Images.)

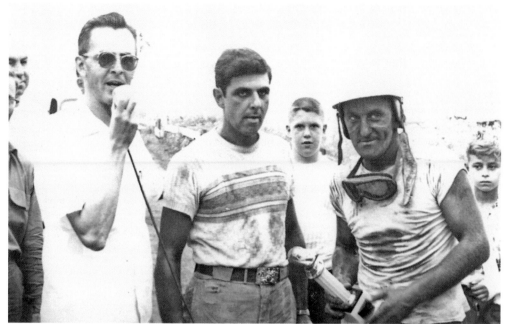

Announcer Johnny Cathers interviews drivers Blackie Reider and Freddy Fehr after a race on the half-mile dirt track. Reider, Fehr, and Ken Wismer Sr. (not pictured) were the biggest winners at Nazareth in the 1953 season. (Courtesy of Walter Howell.)

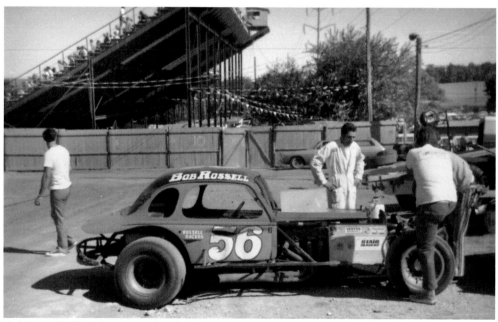

Bob Rossell of Bordentown, New Jersey, looks over his No. 56 car in the pit area during the 1972 racing season. Rossell got the most satisfaction winning in a car he had built and fabricated himself. He was known as a great competitor and his fans admired his smooth driving style on the dirt track. (Courtesy of Jack Kromer.)

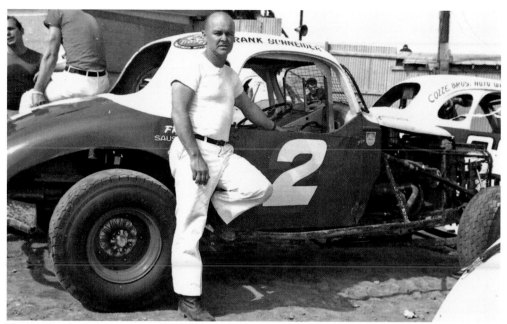

Frank "Frankie" Schneider poses with his No. 2 car in the pits on the half-mile track. He had 64 wins at Nazareth career, a track record. His first win was on July 24, 1960. From 1962 to 1964, he took the checkered flag in 27 out of 100 races at Nazareth, winning three championships. (Courtesy of Scott Peters.)

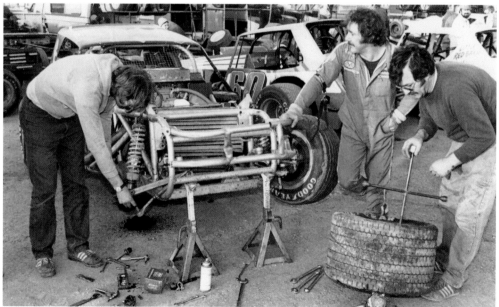

Nazareth resident and track Limited Sportsman champion Randy Bok looks on as the crew repairs his wrecked car. He was the Sportsman champion in 1978 and 1979. In 1982, he won a modified race at Nazareth. He also won six feature races at Dorney Park Speedway. (Courtesy of Jack Kromer.)

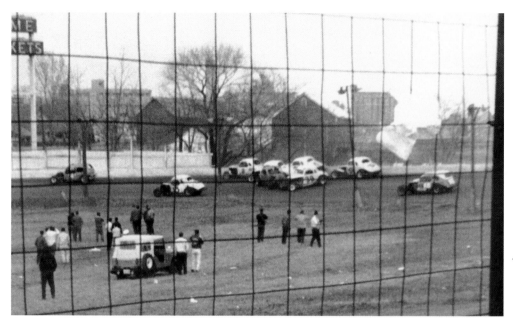

A spectator sitting in the stands photographed this six-car pileup coming out of a turn on the half-mile dirt track. Mechanics and safety crew members wait until the cars stop to assess the situation and see if the drivers are okay. Over the years, the Nazareth skyline, in the background, changed dramatically. (Courtesy of Jack Leach.)

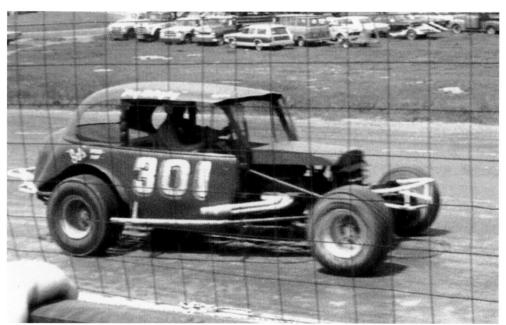

New Jersey driver Craig McCaughey drives along the front stretch in his No. 301 car on the one-mile dirt track. In addition to Nazareth, the also raced at other local tracks. (Courtesy of Jack Leach.)

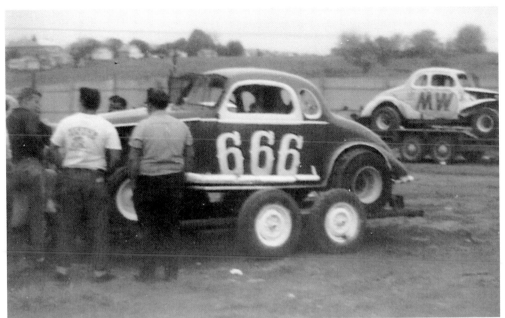

The No. 666 car is looked over in the pits on the trailer before a race in the early 1960s. Del George and Bobby Botcher both drove this car. It was the first Sportsman car that Ronnie Ritter and Jackie Kleintop built. George was badly injured in an accident in this car that left only the frame and roll cage intact. (Courtesy of George Maureka.)

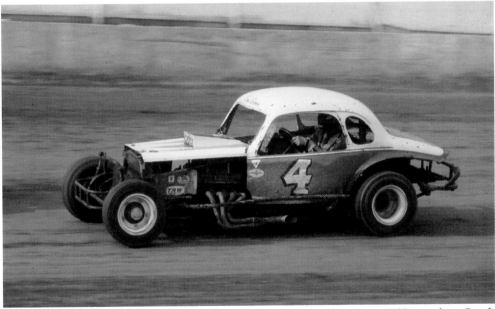

Sonny Strupp in the No. 4 car is making laps on the dirt in a July 1976 race. He was from South Flainfield, New Jersey, and raced from the 1940s to the late 1970s at Nazareth. He had 10 feature wins at Nazareth and two championship titles in 1958 and 1960 at other local tracks. (Courtesy of Jack Kromer.)

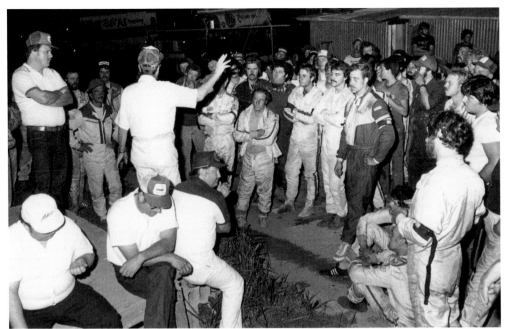

Promoter Jerry Fried, with his back to the camera, raises his hand to get a point across at a drivers' meeting before a July 1982 race on the half-mile dirt track. Meetings like this usually took place before a race to go over new rules, guidelines, payouts, or issues with equipment. (Courtesy of Jack Kromer.)

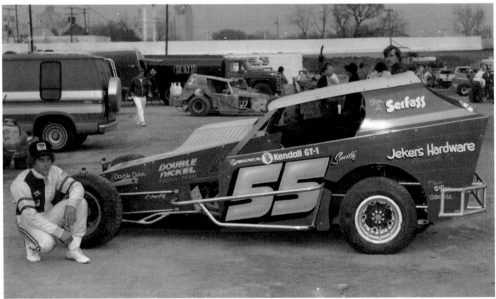

Randy Smith, a young driver from Kunkeltown, poses next to his car in 1985. His No. 55 car had one win on the dirt at Nazareth and also ran at other tracks during his career, from 1983 to 1987. He is currently the owner of S&S Speedways in Stroudsburg and the promoter at Hamlin Speedway in Hamlin, Pennsylvania. (Courtesy of Randy Smith.)

THE DIRT TRACK YEARS

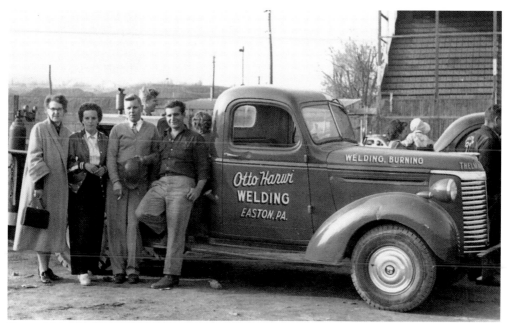

Howard "Otto" Harwi (far right) poses with his family in the infield prior to a Sunday race. From left to right are his mother, Elizabeth Harwi-Meihofer, his wife, Elizabeth Taylor Harwi, and his stepfather. He had a welding business in the neighboring town of Easton and was a local favorite at the track. (Courtesy of Jeff Berger.)

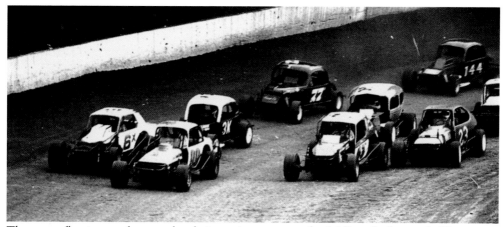

The green flag is waved as cars battle it out in a turn on the 1 1/8–mile dirt track. There were more than 100 drivers listed in the official roster of the Pit Stop racing program, mostly from Pennsylvania, New Jersey, and New York. (Courtesy of Scott Peters.)

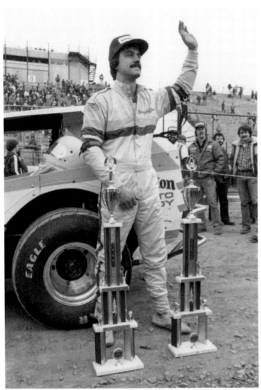

On April 2, 1983, Doug Hoffman of Allentown wins a race at Nazareth's one-mile dirt track. He won 33 Modified features on the half-mile track, winning his last Modified race on August 28, 1988. (Courtesy of Jack Kromer.)

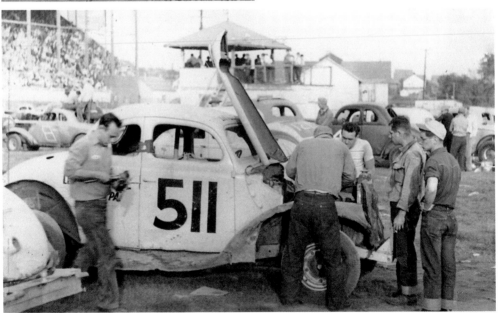

A dedicated team of auto mechanics works on the No. 511 car to get it back on the track. Pitting the cars was done in the infield at this time, in front of the old fairgrounds grandstands. Sometimes, mechanics would do just about anything to get their car back out again. (Courtesy of Jeff Berger.)

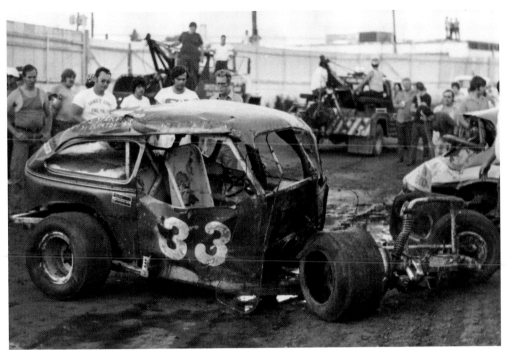

Ed Farley survived this bad wreck in turn three at the half-mile dirt track in the 1970s. The impact was so great that the motor tore out of the car. Here, crew members are in the pits gathering around the wreckage, trying to figure out what to do next and how to prevent this from happening again. (Courtesy of Jack Kromer.)

One tow truck drives backwards while another tow truck hauls a car into the pits on the half-mile track. This was also known as "double hook pickup."(Courtesy of Jack Leach.)

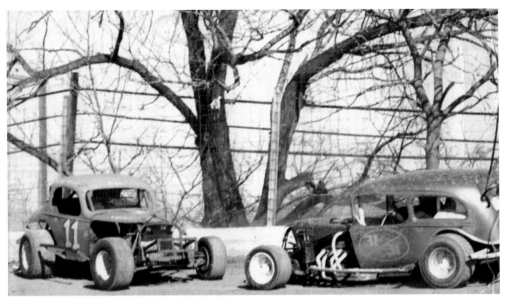

The No. 11 car of John Harroll spins out in front of the No. 31 car, driven by Joe Kelly. Harroll won the championship at Nazareth in 1976 as well as in 1978, even though he did not have a feature win in the latter season. Overall, he won three features at the half-mile track. (Bob Perran Racing photograph; courtesy of Jeff Berger.)

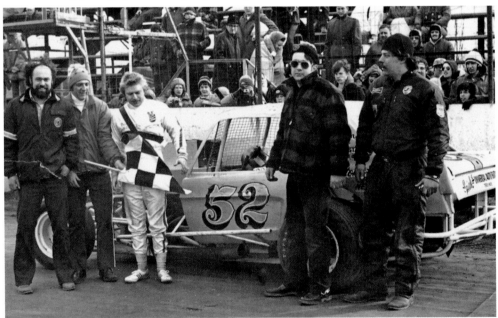

Jackie Wilson of Newburgh, New York, started out racing go-carts and three-quarter Midgets before starting to race stock cars. He is seen here in victory lane after taking the No. 52 car across the finish line first. Later in the season, he was severely burned in this car in a bad crash at Rolling Wheels Speedway in New York. (Bob Perran Racing photograph; courtesy of Jeff Berger.)

Pat Ciambrello, the president of the Liberty Stock Car Racing Association, gives driver Joe "Scrub" Cryan of Oxford, New Jersey, a trophy after Cryan finished in first place. In the background, from left to right, are Jerry Fried, announcer John Cathers, and Ned Fleming of WEST radio. (Courtesy of Walter Howell.)

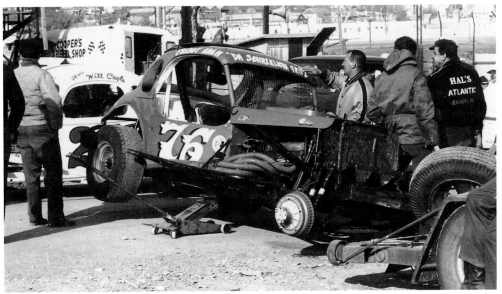

Freddy Adam's No. 76 car is seen here being worked on in the pits. Adam was known as the Kutztown Comet and raced from 1949 to 1986 at more than 40 racetracks in five states. He brought home championships from four of those tracks. In 2011, Paul Weisel Jr. wrote a book about him, *The Life and Times of the "Kutztown Comet": The Freddy Adam Story.* (Courtesy of Jack Leach.)

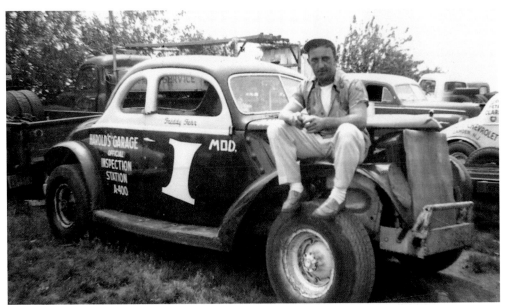

Modified driver Freddy Fehr relaxes on the hood of his No. 1 car in the pits at Nazareth. Harold Cope of Easton provided the car, as well as cars for a few other drivers. During the season, Fehr made more than $2,000 a week, usually finishing in the top three. (Courtesy of Walter Howell.)

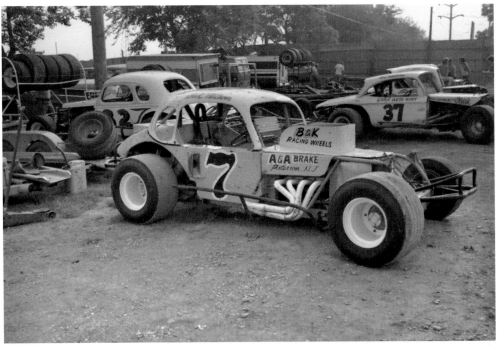

Bill Wilson's No. 7 car, along with Roy Kincaid's No. 32 car and Bill Robin's No. 37 car, sits ready to go in the pits before a 1973 race. The pits were on the outside of the half-mile track. There was a small opening to get cars onto the track. If a car broke down, it stayed in the infield until the race was over and then got towed or pushed into the pits. (Courtesy of Jack Kromer.)

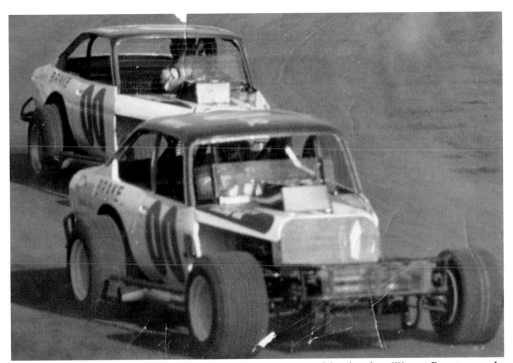

Two No. 00 cars are on the track as Buzzie Reutimann and his brother Wayne Reutimann Jr. battle for position on the dirt track. The Reutimann brothers stayed at a local dairy farm with a garage during the racing season and then went back home to Florida in the winter to race there. (Bob Perran Racing photograph; courtesy of Jeff Berger.)

Limited Sportsman driver Billy Tanzosh, in his No. 4 Tanzosh Special car, beat his teammate Mario Andretti in 1962 and 1963 for the championship. Both Tanzosh and Andretti were local drivers from Nazareth. Between 1979 and 1981, Tanzosh had five wins at Nazareth. He also won a single Modified feature in 1979. (Courtesy of Jack Leach.)

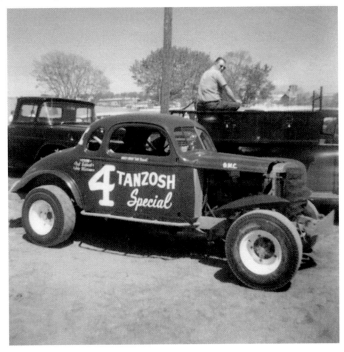

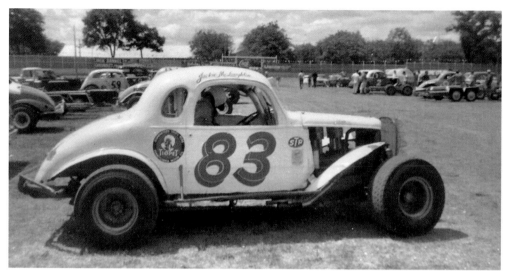

Jackie McLaughlin's No. 83 car is ready to go racing as it sits in the pits at Allentown. McLaughlin started his racing career at age 17 and his brother-in-law Budd Olsen talked him into racing Modifieds at Nazareth. He won 24 races here but died tragically a day after he sustained severe injuries from a horrific crash. He was only 30 years old. (Courtesy of Jack Leach.)

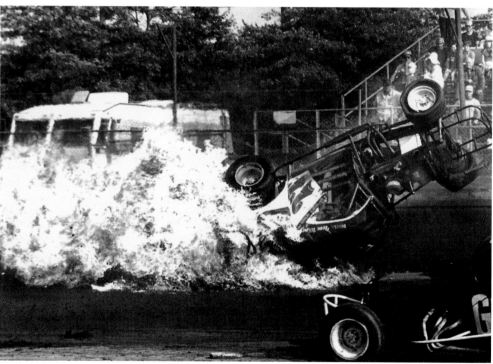

Although fiery crashes are relatively rare at any track like this one at Flemington, they do happen. The racing fuel in the cars is very flammable and the smallest spark in a rollover or a crash can ignite it, causing a fireball. Spectators watching the race were only a few feet away from this heated crash near the grandstands. (Courtesy of Jeff Berger.)

THE DIRT TRACK YEARS

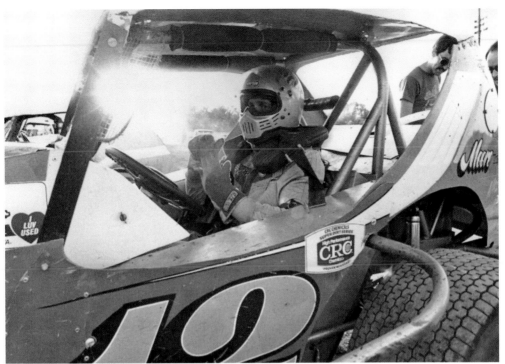

Former track champion Kevin Collins of Nazareth puts his racing gloves on and checks to be sure everything is all right before taking his No. 12 car to the half-mile track in 1981. He had an impressive 31 feature wins at Nazareth from 1976 to 1986. (Courtesy of Jack Kromer.)

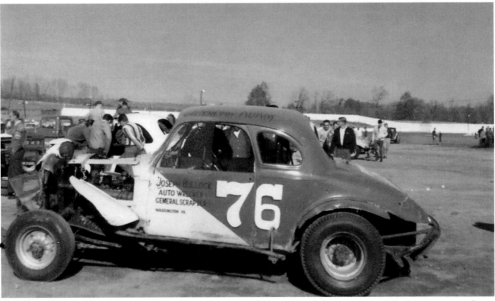

Freddy Adam's No. 76 car sits in the pits at Middletown. Adam grew up in Kutztown, where his father told him at a young age that he would be a race car driver. He was inducted into the National Racing Hall of Fame in 2006. (Courtesy of Jack Leach.)

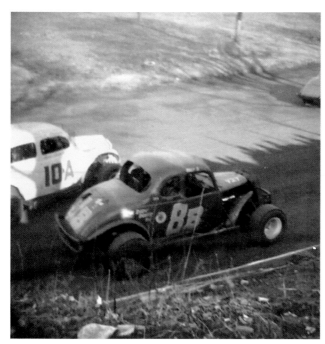

The No. 8B and No. 10A cars battle it out for position in an Easter Sunday race in 1964. Sometimes, cars would get too close to each other and "share" or "swap" paint with another car. This was not a big deal unless it was the same car constantly doing it to one car throughout the race. (Courtesy of George Maureka.)

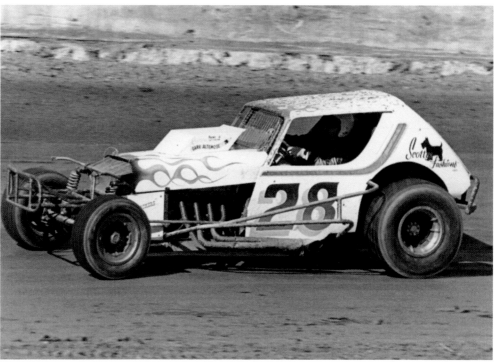

Tighe Scott of Pen Argyl, seen here in the No. 28 car, raced at Nazareth for many years before going on to NASCAR, where he almost won the Daytona 500 in 1979. Later, he drove Sprint Cars in central Pennsylvania. He is seen here running drag-rubber tires on his way to victory at Nazareth in 1975. (Courtesy of Jack Kromer.)

THE DIRT TRACK YEARS

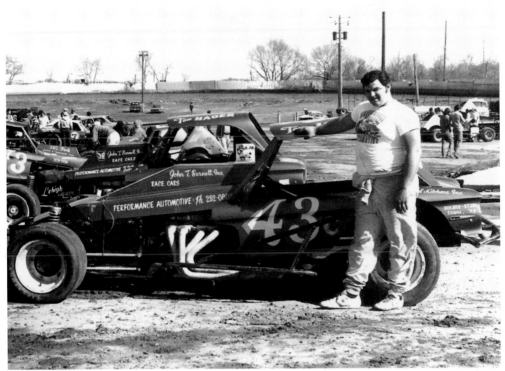

Tom Hager poses next to his No. 43 car in the pits outside the dirt track. He grew up nearby in West Easton. At Nazareth, he won 38 features and two track Modified titles. Overall, he had more than 160 wins at tracks in Pennsylvania, New Jersey, and New York. (Courtesy of Scott Peters.)

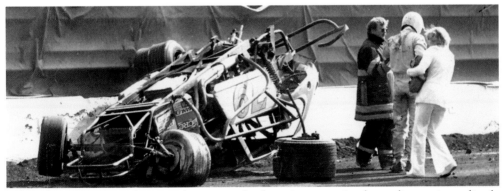

When fans see an accident on the racetrack, there is a gasp in the audience, immediately followed by the red flag to stop the other drivers. Rescue personnel and medics rush to the car. At Syracuse, the grandstands are silent until the driver gets out of the car, when the crowds clap and cheer that the driver is—or at least appears to be—fine. (Dan Golden photograph; courtesy of Jeff Berger.)

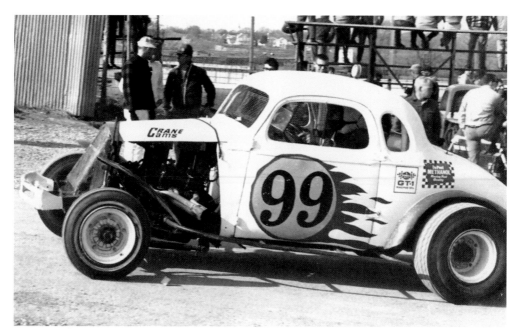

While running in a few NASCAR races in the South, Bob Malzahn heard about the racing action up north. He settled in New Jersey, where he picked up championship titles at Old Bridge, Wall, and New Egypt. He won the 1958 national championship in Trenton, but, two days later, NASCAR notified him that there had been a mistake and that Budd Olsen won instead, dropping Malzahn to third in championship points. (Courtesy of Jack Leach.)

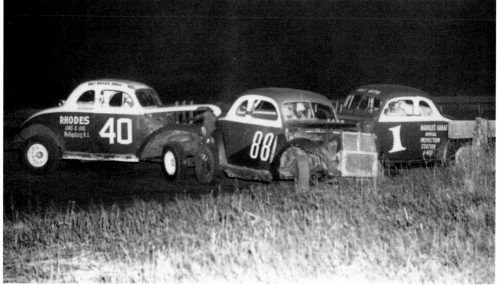

Harry Charles in the No. 40 Freddy Fehr in the No. 88 and Otto Harwi in the No. 1 cars spin out in a turn on the half-mile dirt track. All three of these drivers frequented victory lane often during their racing careers. At Nazareth, Charles had 6 wins, Fehr had 12, and Harwi had 39. (Courtesy of Walter Howell.)

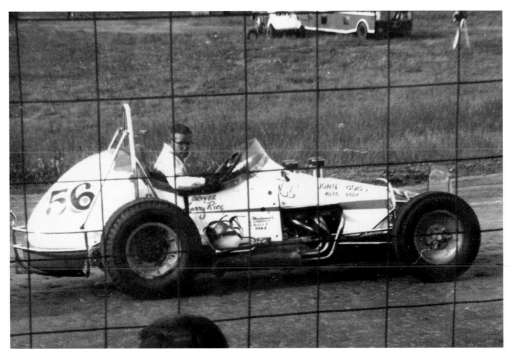

URC Sprinter Larry Rice of Little Falls, New Jersey is driving his sprint car on the United Racing Club's half-mile dirt track. He also drove midget cars in the ARDC. Tragically, he lost his life in a midget auto race at Islip Speedway on August 16, 1969. (Courtesy of Jack Leach.)

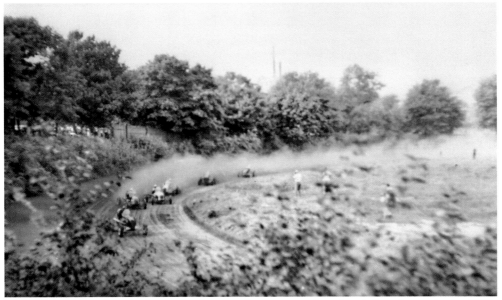

Here, the track looks a little rough, dusty, and overgrown, but that is how it was in the 1950s during Sprint Car races on Nazareth's half-mile track. Over the years, many trees were cut down around the track, and a new, bigger track was built on top of the hill near the half mile track. (Courtesy of Jack Kromer.)

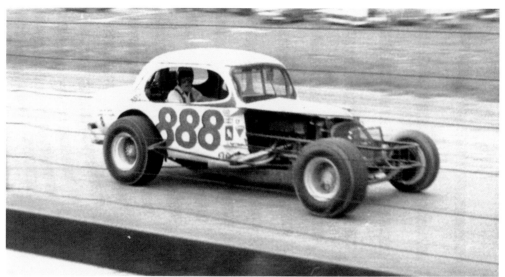

The first car that Wayne Young drove was rescued from an old salt mine in South Side, Easton, Pennsylvania in 1965. His family then bought this former No. 711 car from Dave Kneisel and renumbered it No. 888. They converted it into a sportsman and won races with it. Wayne Young currently lives in Phillipsburg, New Jersey. (Courtesy of Jack Leach.)

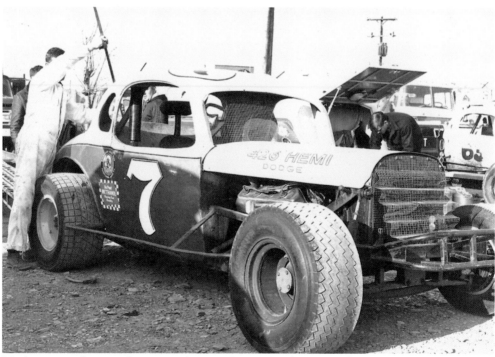

Mechanics are busy in the pits working on Leon "Cowboy" Manchester's No. 7 car. A former bull rider, he was recruited by Jackie McLaughlin when he was racing in the South. On the half-mile dirt track, he was one to put on a show for the spectators. His mechanics were convinced that pieces of the fence from the track were part of his car. (Courtesy of Jack Leach.)

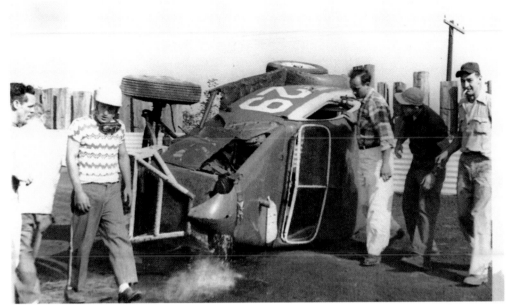

Freddy Fehr (left, in helmet) walks from his overturned No. 29 car during an October race in 1964. It was the second time that day he had managed to turn the car over. Harold Cope (third from right), the owner and builder of the car, evaluates the damage. A few years later, the car was purchased by Ed Pados Sr. (Courtesy of Walter Howell.)

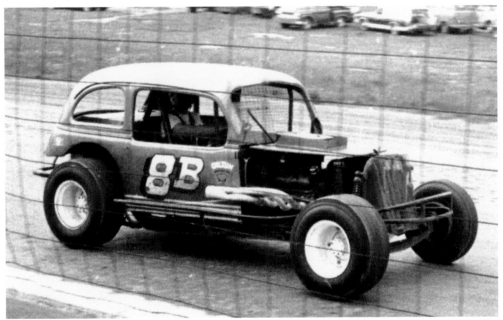

Billy Deskovick, also known as "Billy D," from Hanover, New Jersey, races his No. 8B car on the front stretch on the half-mile dirt track. He drove from 1952 to 1981, mostly in Pennsylvania, New Jersey, and New York. He also built race engines for other racers for more than 30 years. (Courtesy of Jack Leach.)

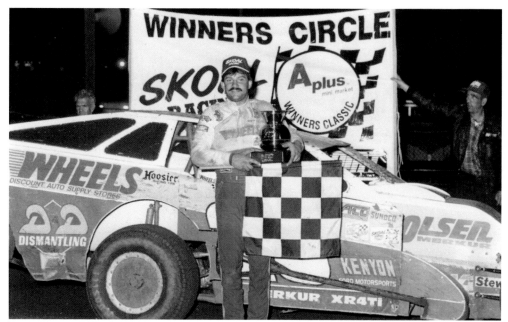

Brett Hearn smiles for the cameras in victory lane after taking the checkered flag. Hearn went down in history as the last Modified driver to win on the half-mile track. Within weeks of the win, the track was torn down to make room for a strip mall and a grocery store. (Courtesy of Jack Kromer.)

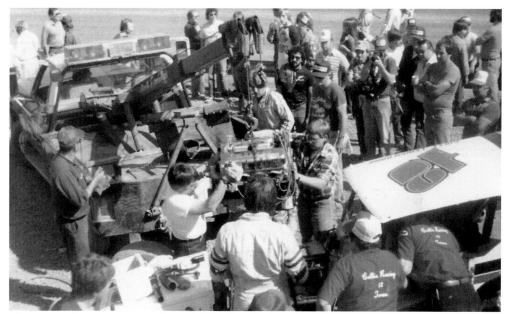

There was always action in the infield, either before, during, or after a race. Here, a crew of mechanics drops an engine in the No. 12 car. Collis Racing Team was a popular team on dirt. They were locals from Northampton who brought a lot of fans to watch them race—and win. (Courtesy of Jeff Berger.)

THE DIRT TRACK YEARS

The No. 28 car of Tighe Scott, of Pen Argyl, is seen here on the dirt track in the mid-1970s. His dad owned Scotty's Fashions, one of the car's sponsors. (Courtesy of Jack Kromer.)

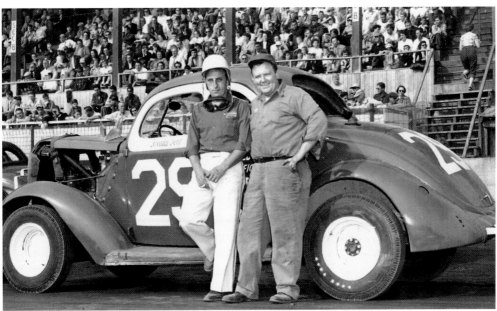

Freddy Fehr, the driver of the No. 29 car, poses in front of the filled grandstands with car owner and builder Howard Cope. The two men, both from Easton, spent many happy times in victory lane. After Fehr's racing career, he still liked to be number one, and he was the *Morning Call* newspaper's district sales manager of the year for five years in a row before he retired. (Courtesy of Walter Howell.)

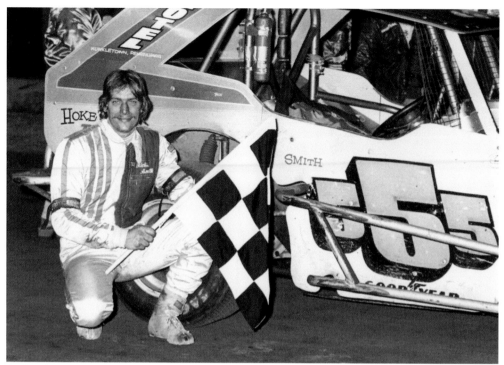

A fan favorite at the racetrack was Kunkletown's Richie Smith, who is seen here in victory lane again after taking the checkered flag with his No. 555 car in a May 1982 race. He had an impressive 17 feature wins at Nazareth from 1979 to 1986. He also raced against his brother Randy on occasion. (Courtesy of Jack Kromer.)

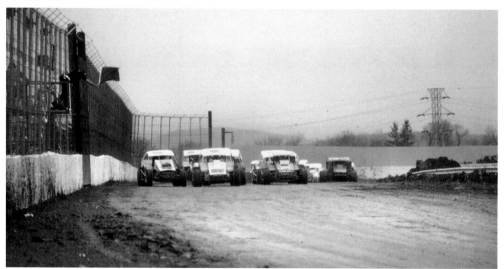

Johnny Kozak, in the No. 31 car, and Dave Hahn, in the No. 2 car, lead the field to the green flag at the reopening race in December 1982. The race was cut short due to darkness. At the time, the track was called Nazareth National Motor Speedway, which Lindy Vicari promoted it as for a short time. (Courtesy of Jack Kromer.)

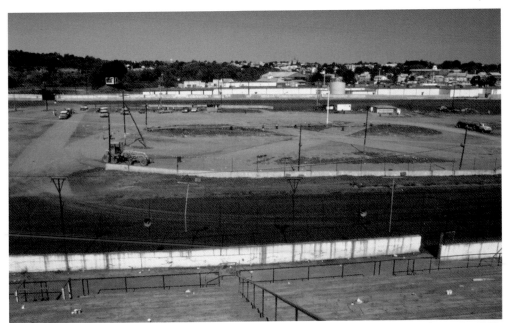

The Nazareth half-mile is seen here in 1983, about five years before it was torn down. In 1988, the checkered flag was waved for the last time on the track, and a strip mall and grocery store were built almost where the infield was. (Courtesy of Jack Kromer.)

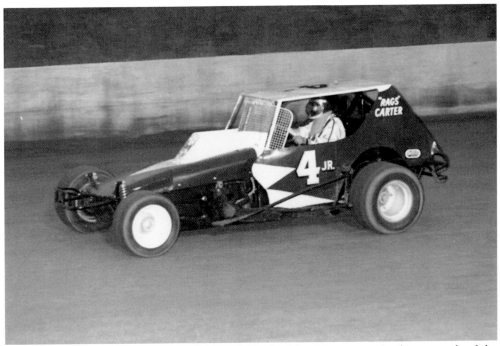

Alan "Rags" Carter of Oley, Pennsylvania, drives his No. 4 Jr. car on the front stretch of the one-mile dirt track. Carter had a record 11 wins in 1965 and 1966. He is second, behind Frankie Schneider, in wins at Nazareth between 1950 and 1986. (Courtesy of Scott Peters.)

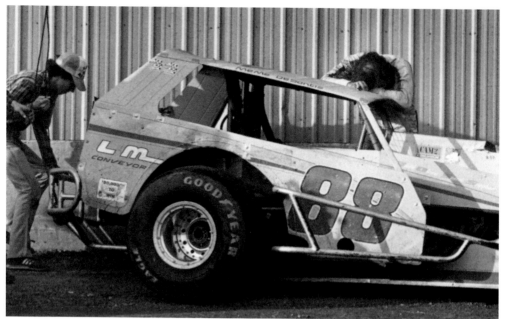

Meme DeSantis of the No. 88 car puts his head down in disbelief as a tow truck hooks him up after he crashed on the one-mile track in 1983. He still continues to race today at several local dirt tracks including Grandview and Big Diamond Speedway. (Courtesy of Jack Kromer.)

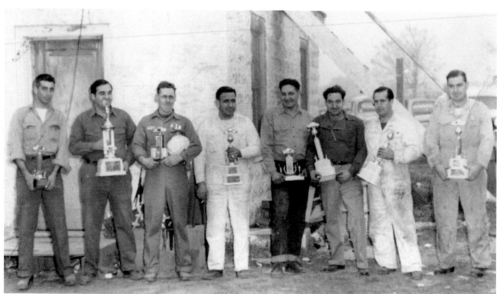

These drivers are all smiles as they pose for the photographer with their trophies. They are, from left to right, Norm Pleiss, Buddy Burgstresser, Harry Charles, Harold Brokhoff, Kenny Wismer, Smokey Dengler, Otto Harwi, and Shorty Kershner. Over the years, many of these drivers acquired trophy collections that were proudly displayed in their garages and homes. (Courtesy of Jeff Berger.)

THE DIRT TRACK YEARS

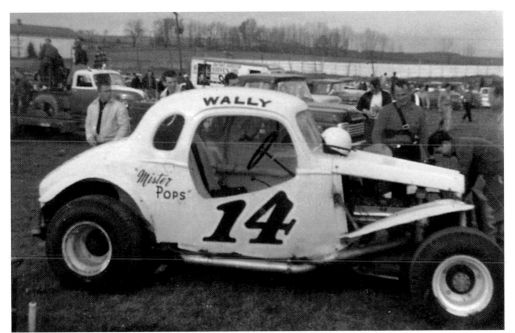

Wally Dallenbach Sr. of East Brunswick Township, New Jersey, parks his No. 14 car in the pits. He later went on to drive in 180 Indy Car races between 1965 and 1979. He was also inducted into the American Motorcyclist Association's Motorcycle Hall of Fame and the Colorado Motorsports Hall of Fame. His son Wally Jr., a NASCAR driver and commentator, followed in his dad's footsteps. (Courtesy of Jack Leach.)

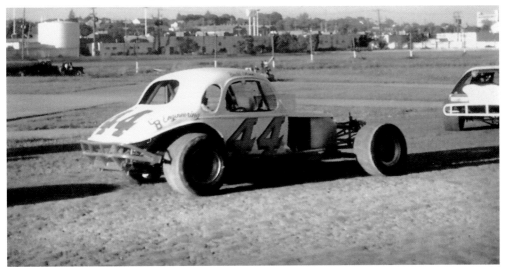

Budd Olsen of Paulsboro, New Jersey, started his racing career in 1948 after serving in World War II. He drove many different cars, including Harold Cope's No. 1 Ford coupe, "Lucky" Jordan's No. 2 car, and the No. 44 seen here. He became the National Auto Racing Association champion in 1951. He retired from driving in 1973 and went on to build hundreds of race cars in his New Jersey shop. (Courtesy of Scott Peters.)

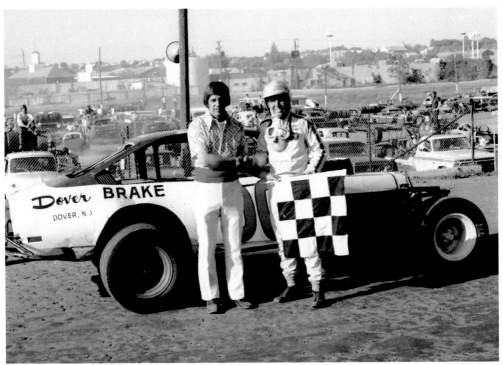

Emil L. "Buzzie" Reutimann poses next to his No. 00 car in victory lane. He got the nickname Buzzie just minutes after he was born, when nurses said he was making a buzzing sound. He went on to win 33 races on the old half-mile track as well as two championships, in 1972 and 1973. (Courtesy of Bob Snyder.)

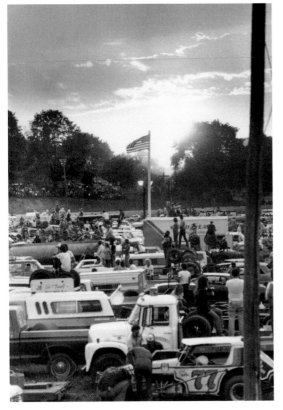

The sun sets behind the trees on the infield flag in the half-mile pits. On this warm August evening in 1981, many crew members and drivers chose to watch the race in the infield from the roofs of their trucks or trailers. (Courtesy of Jack Kromer.)

THE DIRT TRACK YEARS

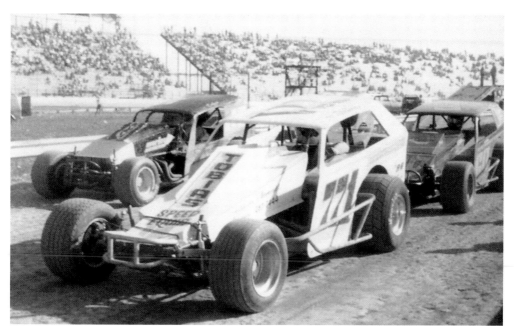

Fred Rahmer, in the No. 771 car, prepares to go out on the track. He won 33 Sprint Car feature races in the 1998 season. He also became the nation's winningest Sprint Car driver that same year and received an award from the Eastern Motorsport Press Association (EMPA). In 2013, he retired from racing. His two sons, Brandon and Freddy Jr., are following in his footsteps. (Courtesy of Jeff Berger.)

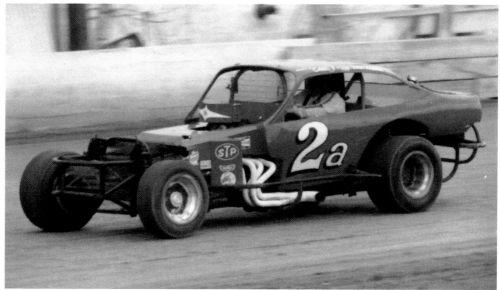

The No. 2A car of Carl "Fuzzy" Van Horn of Phillipsburg, New Jersey, is seen here on the track. Van Horn set a track lap record in 1974. At one time, he owned the NASCAR track near his hometown. Although he lost the track a while later after an accident, he held onto his car, going back to racing. He won his first feature at Nazareth in 1956. (Courtesy of Scott Peters.)

Jerry Fried did very well in marketing the track, bringing in exciting racers and filling the grandstands. In the 1960s and 1970s, he sent full-color postcards to many racing fans, with the schedule for the upcoming season on the back. They were small in size but perfect for putting on the refrigerator door. (Courtesy of Scott Peters.)

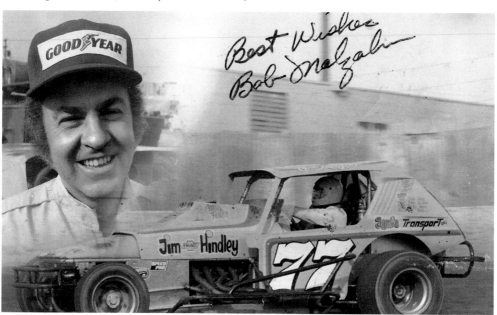

Bob Malzahn, a driver from Matamoras, Pennsylvania, is seen here with his No. 77 Modified. He also drove the No. 99 car. He won his first feature race in 1959 and went on to win 26 races at Nazareth. He raced his Ford in one NASCAR race, in Raleigh, North Carolina, placing 48th out of 55 cars. (Photograph by Bob Hess; courtesy of Jeff Berger.)

The pits were full of action in the mid-1960s. Here, drivers and crews prepare their cars to be sure that everything will run well on the track. Tires had to be checked for the right amount of pressure, fluids had to be checked, and drivers had to suit up in their racing apparel. (Courtesy of George Maureka.)

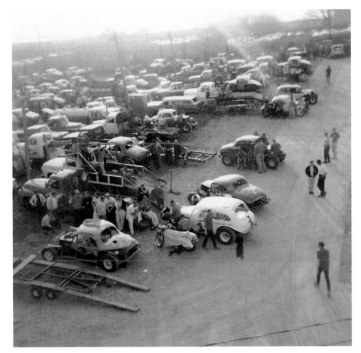

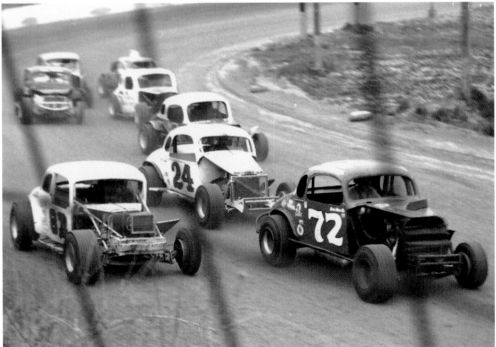

A spectator in the grandstands captured this racing action coming out of a turn on the half-mile dirt track. Sometimes, spectators would come home from the track with a layer of dirt on them, as well as on everything they had brought with them. In the pits, it was no different, and crew members had to keep their tools and equipment covered. (Courtesy of Jack Leach.)

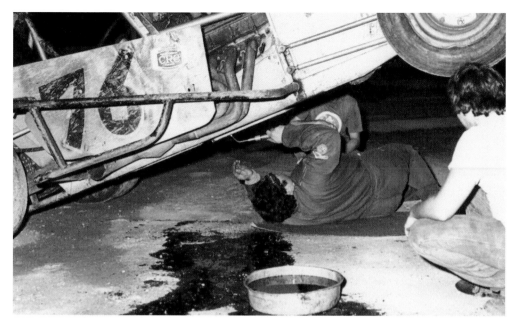

Tom Hager is busy at work in the pits, welding on the No. 76 car. He was known as an innovator and a good engineer who worked on his own cars. During one race, just before they took the green flag, he pulled his car to the side of the track and went into the infield men's room. Everyone waited until he got back in his car to start the race. (Courtesy of Jack Kromer.)

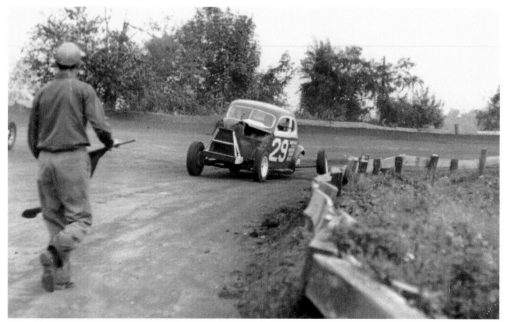

Harold Cope's No. 29 car is seen here with a small tire problem on the dirt track. The flagger is going to the car to investigate. Usually, flaggers are the first to report on problems at the track to the promoter. As the years went by, radios and two-way communications made this process easier. (Courtesy of Walter Howell.)

THE DIRT TRACK YEARS

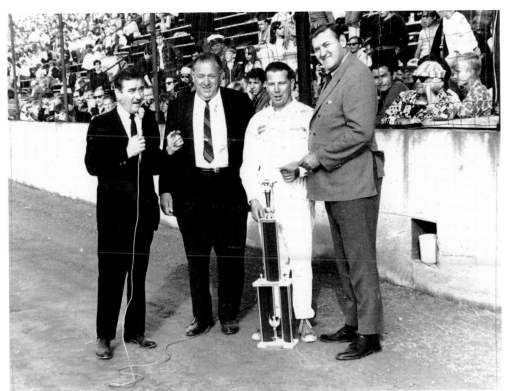

Promoter Jerry Fried (far left) announces race winner and Florida native Will Cagle, the driver of the No. 24 car. He came to the area in 1959 with his 1936 Chevy Coupe, which was 350 pounds overweight. He learned more about racing and, in 1967, was crowned Modified champion. (Photograph by Dave Innes; courtesy of Jeff Berger.)

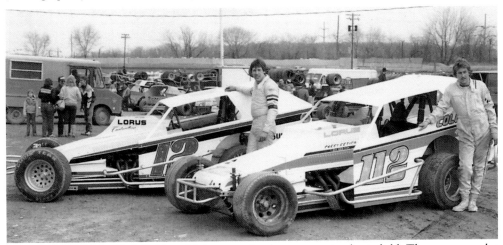

The Collis brothers, Carl (left) and Jake, pose for the cameras in the infield. They were regular Modified drivers in the 1980s. Carl usually had a better car and better equipment than his younger brother, but both performed quite well on the dirt track. Their family owns a junkyard and truck business nearby in Northampton. (Courtesy of Scott Peters.)

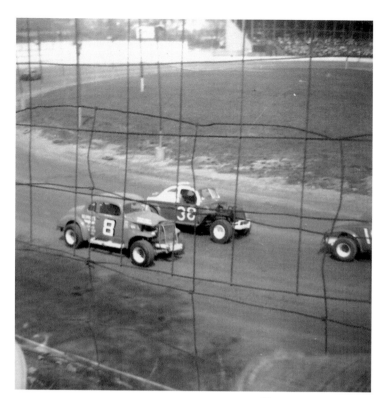

Cars battle it out after coming out of a turn. In the background are the old grandstands, which were brought over from the original fairgrounds site in town. They remained there for many years until they were destroyed by fire; newer ones were built for the following season. (Courtesy of George Maureka.)

Carl Collis poses with the two trophies he has just won at the dirt track. It is believed that he won on both tracks on the same day. He won the 40-lap Modified stock-car event in 1984, the last race run by promoter Lindy Vicari before the track went bankrupt a year later. (Courtesy of Jeff Berger.)

THE DIRT TRACK YEARS

Local favorite Frank Cozze, from the neighboring town of Wind Gap, races his No. 44 car under a full moon at the half-mile dirt track in 1987. He had switched from racing Modifieds to racing Sprint Cars and in 2013 ran modifieds. He had 17 career feature wins at Nazareth, between 1976 and 1988. (Courtesy of Jack Kromer.)

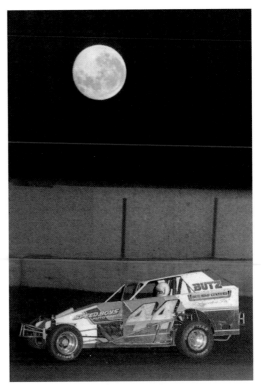

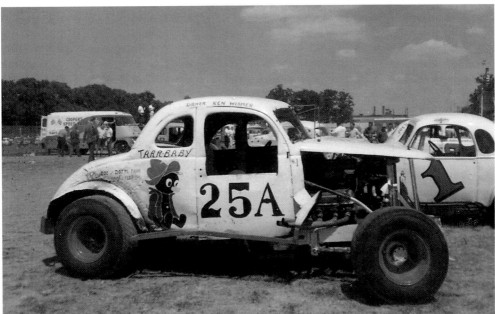

Ken Wismer Sr.'s car sits in the pits ready to go racing. The Riegelsville, Pennsylvania, native was a champion in 1954 and won 19 Modified feature wins at Nazareth during his racing career. He had a "Tarbaby" painted on his car since Dr. Don Tarr was the owner of the car. (Courtesy of Jack Leach.)

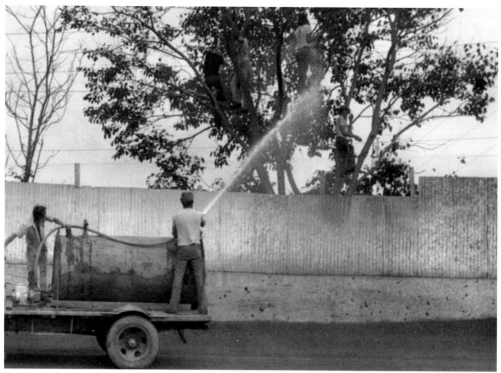

During a break from the racing action in 1979, Ward Crozier takes the track water truck and hoses down fans clinging to the trees outside of turn one, who did not pay admission to see the race. (Courtesy of Jack Kromer.)

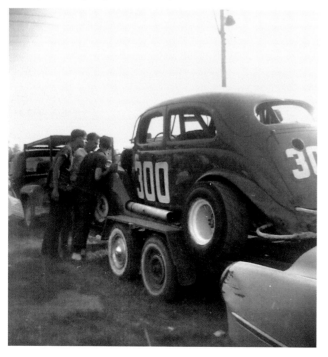

A few people check out what is under the hood of the red-and-white No. 300 car of Bobby Pickell Sr. The native of Flemington, New Jersey, had 14 wins at Nazareth, winning his first race on May 24, 1964, and his last on March 14, 1976. He also raced at six other tracks in his career, retiring with 36 career wins and quite a few top-five finishes. (Courtesy of George Maureka.)

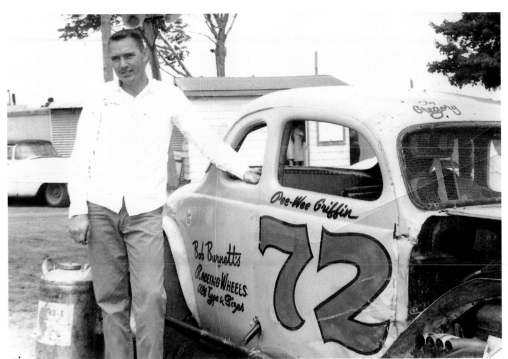

Pee Wee Griffin poses next to his No. 72 car in the pits in 1964. He was from Hughtstown, New Jersey, and won four features at Nazareth. He had more than 250 wins in his racing career and was a six-time champion at East Windsor Speedway. In the 1980s, he had legal troubles involving drugs. (Courtesy of Jeff Berger.)

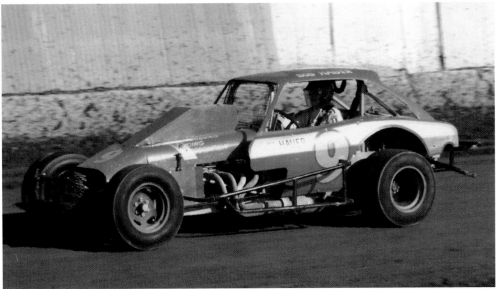

Bob Hauer of Orwigsburg, Pennsylvania, is seen here on the dirt track with his No. 9 car. He had one win at Nazareth in 1977. He went on to race at other local tracks, where he did quite well. (Courtesy of Scott Peters.)

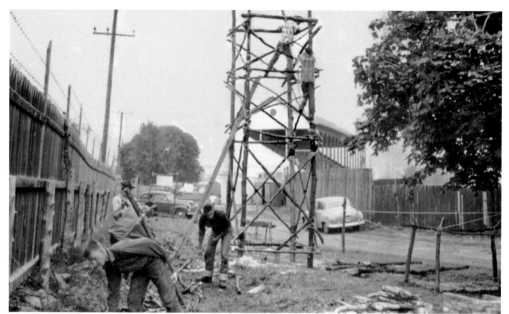

Near the grandstands during the 1953 Nazareth fair, Boy Scout Troop No. 79 sets up a signal tower and a campsite for Scouts to have sleepovers. They made hot dogs with sauerkraut and put out donation jars. The money they made during the fair was enough to keep their troop going all year. (Courtesy of Darrell Mengel.)

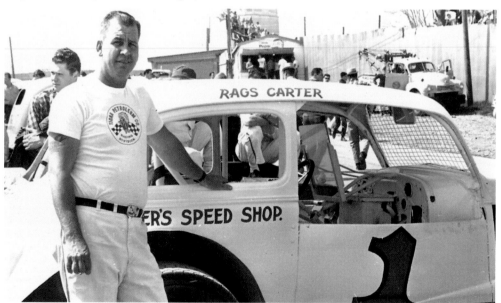

Alan "Rags" Carter stands next to his No. 1 car in the pits. He got his name when visiting New York after a delivery, when his layers of torn clothing from battery acid made him look like a "Rag Doll," which was later shortened to "Rags." He was a family man and a dedicated father who traveled with his children all over the country. His son Alan Jr. became a racer himself. (Courtesy of Scott Peters.)

This panoramic view of the half mile dirt track looks out to the outskirts of Nazareth, with Routes 191 and 248 in the distant background. There were a few cement plants in the area, and promoter Jerry Fried was convinced that they created the "extra dust" seen on race days. (Courtesy of George Maureka.)

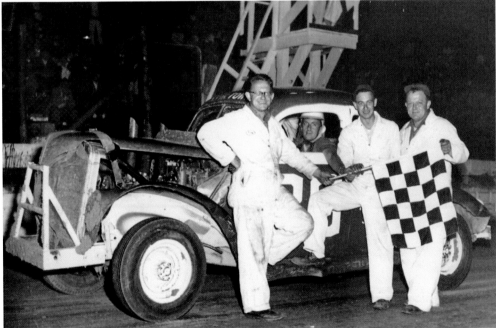

Freddy Fehr, in the red-and-white No. 29 car, poses for a photograph in victory lane with his mechanics (from left to right) unidentified, Lou Muffley, and Harold Cope. Fehr had 12 career wins, from 1953 to 1958. (Courtesy of Walter Howell.)

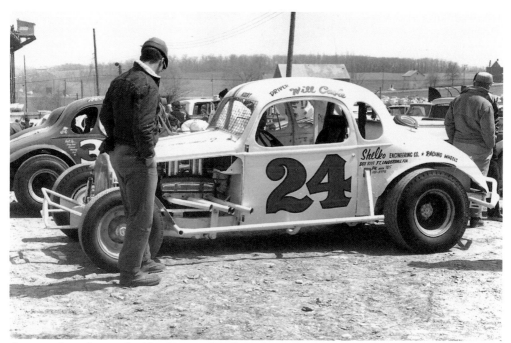

A racing fan admires the No. 24 car of Will Cagle in the pits. In 1968, the No. 24 car did not make the minimum height. The next week, Cagle brought in a car from a scrap pile that was called "Willie's Wreck," but his roof kept ripping off as he was holding onto it, and he was black-flagged. Cagle, "the Tampa Terror," won 40 races at Nazareth, starting in 1963. (Courtesy of Jack Leach.)

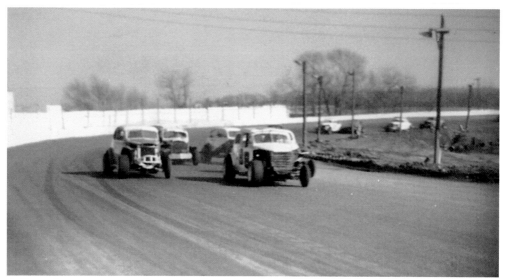

A fleet of cars comes out of a turn on the old dirt track. The tires of the cars were almost always staggered, with a smaller one on the left front to grip the track better, turn better, and possibly prevent the car from rolling over. Sometimes, tires were grooved for better traction as well. (Courtesy of George Maureka.)

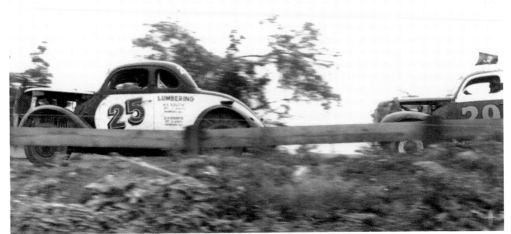

Two cars compete for a better position on the dirt track. Wooden guardrails were installed in some places on the track to avoid accidents such as rollovers, which could occur if a car got too close to the edge. Later, when the track became asphalt, the wooden rails were replaced with steel guardrails. (Courtesy of Walter Howell.)

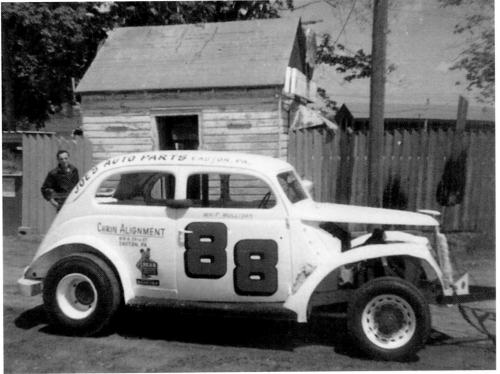

George "Whip" Mulligan's No. 88 car is seen here at the pit shack, waiting to be registered for the race. He won several races at Nazareth and one championship and was close to winning the all-star league crown in 1968. It came down to the last race, when, with a few laps to go, his tire blew out and he hit the wall. (Courtesy of Jack Leach.)

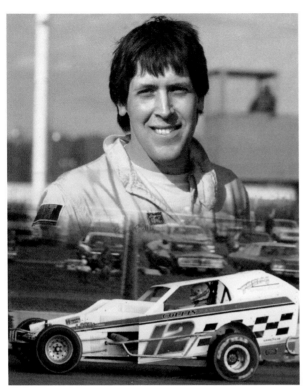

Northampton native Carl Collis, in his No. 12 car, won the 200-lap Northeastern States championship race in 1986. He had the most wins in 1984, with 14. Between 1980 and 1986, he went to victory lane 29 times. His brother Jake also raced with him on the dirt. (Courtesy of Jeff Berger.)

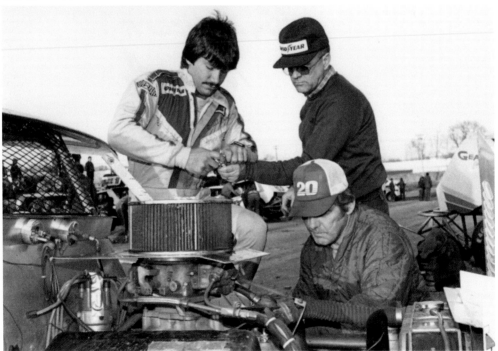

Brett Hearn works on his motor in the pits at Nazareth with a crew member and his father, Gordon Hearn (wearing the "20" hat), in April 1982. (Courtesy of Jack Kromer.)

Racers compete for position on a turn in the dirt. Spectators sometimes climbed the trees along the track to see the racing action without paying grandstand admission. The water trucks would then come out during breaks and use their water hose to spray the tree climbers until they got off. (Courtesy of George Maureka.)

Jerry Wilson of North Haledon, New Jersey, is seen here in the No. 36 car on the dirt track. Wilson's family still owns Haledon Auto Parts in Haledon, and they have been known to help out a lot of racers over the years. (Courtesy of Jeff Berger.)

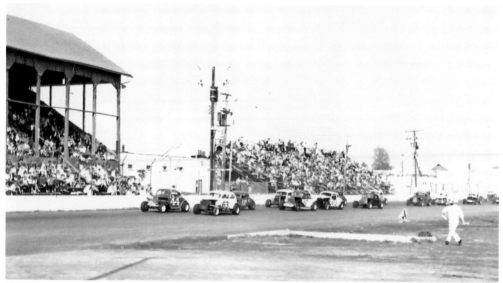

Cars wait at the starting line as the flagger gets ready to wave the green flag. Sometimes, the flagger was part of the show, entertaining the crowd in the grandstands. Initially, the flagger started races from between the cars on the track before moving into the infield years later. (Courtesy of Scott Peters.)

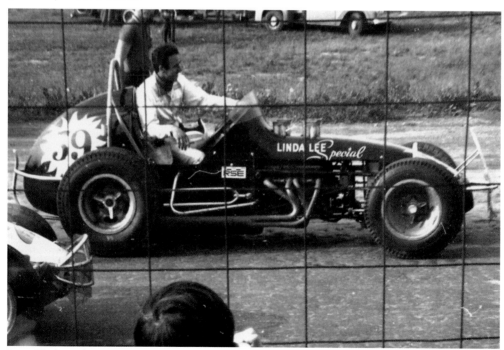

Jerry Karl ran his No. 59 URC sprinter for 16 seasons, from 1969 to 1984. In 1980, he passed Mario Andretti at a CART race in Phoenix before having to go to the pits with engine problems. In addition to racing, he also had a pilot's license to fly aircraft and helicopters. (Courtesy of Jack Leach.)

One of the cement plants' towers is seen here beside the 1 1/8–mile dirt track, along Route 191 near Georgetown Road. Cement workers had a good view of the racing action on race day. The track was eventually shortened so that it did not go out to the road as much, and more parking lots were built there. (Courtesy of George Maureka.)

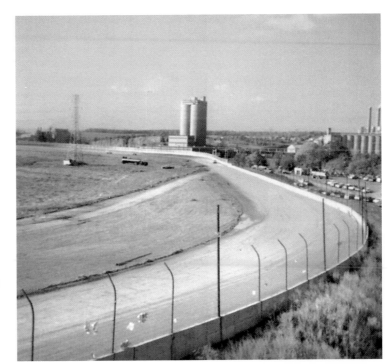

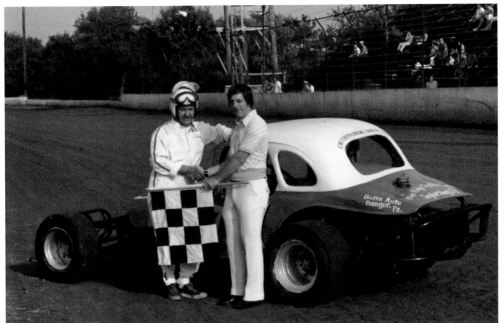

Don Lawson of South Bound Brook, New Jersey, with flagger Ken Golden, poses with his No. 777 Sportsman car after the first of his three feature wins at Nazareth. This car was owned Leo Reinhart. He earned a championship at Circle K Speedway in Whitesville, New York, in 1981. He also raced at other tracks in Pennsylvania, and he currently races at Woodhull Raceway in New York. (Courtesy of Don Lawson.)

The No. 38 car is towed off the dirt track. When a driver senses that something is wrong with the way a car is handling, sometimes he or she will drive it into the pits. When they cannot, however, a tow truck is brought in from the infield to take it to the pits. (Courtesy of George Maureka.)

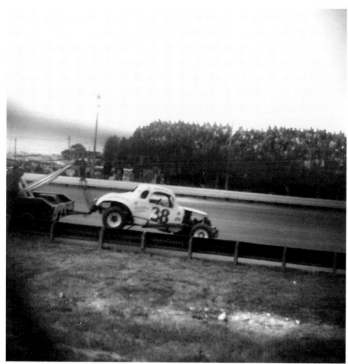

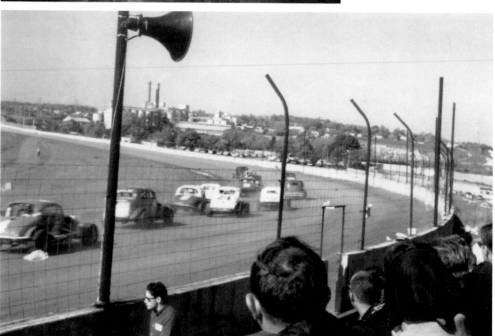

Drivers put the pedal to the metal as they take the green in turn one of the one-mile dirt track. One of Nazareth's cement plants is seen in the background. People sometimes congregated on the rooftops of homes or at Indian Tower to get a good (and free) view of the racetrack. (Courtesy of George Maureka.)

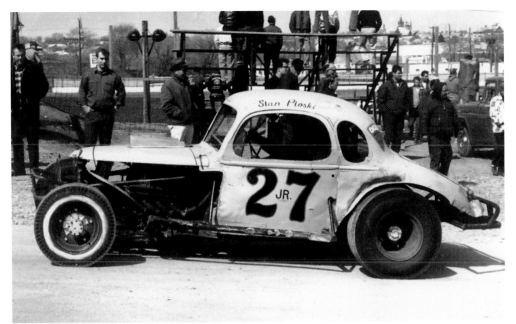

Stan "The Man" Ploski Jr., from Ringoes, New Jersey, traveled a lot during the racing season. In his No. 27 car, he was a popular and successful Modified driver. In one legendary weekend, he won the checkered flag on Friday at East Windsor, on Saturday afternoon at Flemington, on Saturday night at Reading, and on Sunday at Nazareth's half-mile. (Courtesy of Jack Leach.)

There is a different type of excitement in the air when a family member or friend takes the checkered flag. Spectators are seen here on their feet in the grandstands, hoping their favorite driver wins. When the race was over, crew, family, and fans flock to victory lane to congratulate the driver and pose for photographs. (Courtesy of George Maureka.)

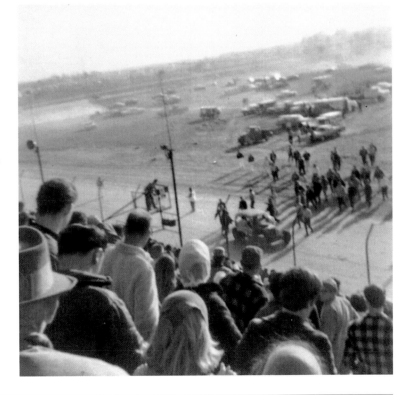

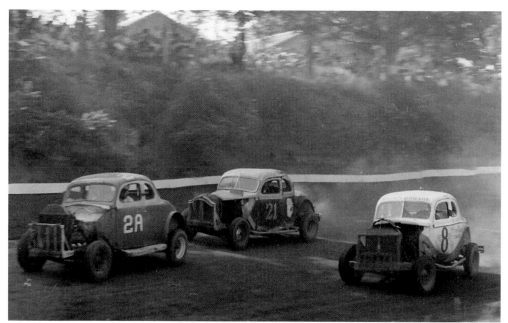

The No. 2A, No. 21, and No. 8 cars battle it out in a turn on the dirt. Drivers going into a turn had to decide quickly what to do—go high or go low—to hopefully pass another driver. Sometimes, drivers stayed in the same line for a few laps as they worked on a strategy to pass. (Courtesy of Jeff Berger.)

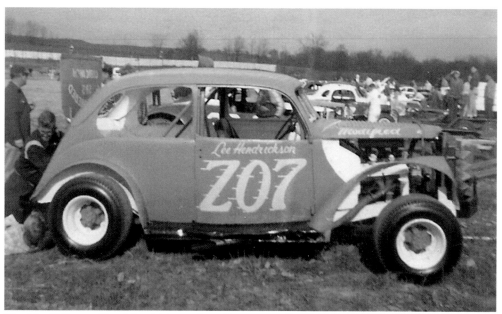

The No. Z07 car of Lee Hendrickson, from Lawrenceville, New Jersey, sits in the pits ready to go racing. Hendrickson was in the All-Star Racing League and also raced the No. Z01 car on the dirt. His son Wade followed in his father's footsteps and currently races Modifieds in New Jersey. (Courtesy of Jack Leach.)

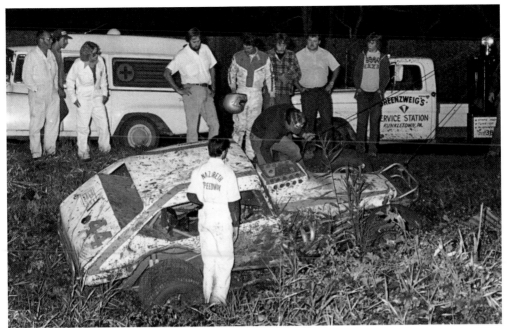

Frank Cozze almost ended up in the second-turn pond after a crash in his No. 44 car in 1978. Track and ambulance personnel were on hand to access the situation. The pond was where the water trucks got the water to wet down the half-mile dirt track. (Courtesy of Jack Kromer.)

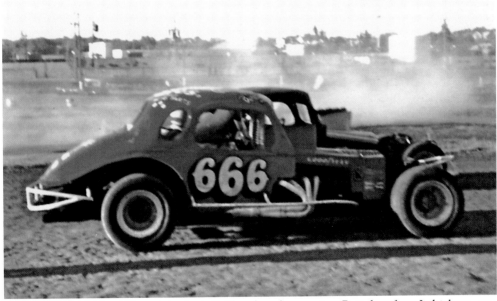

Bobby Bottcher's No. 666 car is in the infield and ready to racing. Bottcher, from Lehighton, was known as a very good driver. He had an impressive 32 wins at Nazareth between 1967 and 1980. His son Steve also had one win and tied for a championship at Nazareth in 1982. The dust in the background was from a figure-eight race taking place on the infield. (Courtesy of Scott Peters.)

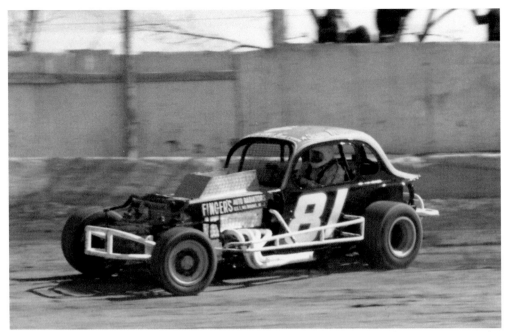

Sammy Beavers of Whitehouse Station, New Jersey, races around a turn in his No. 81 car on the half-mile dirt track. He had total of 14 wins during his career at Nazareth, from 1968 to 1979. (Courtesy of Scott Peters.)

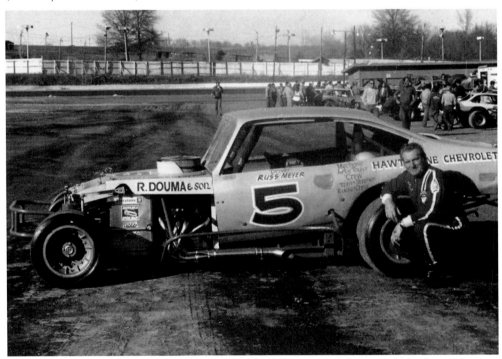

Russ Meyer poses in the pits for a photograph at Middletown with his prized No. 5 car. He ran a few races on the half-mile track at Nazareth. (Courtesy of Jeff Berger.)

After a wreck or a part failure, a welder is a racer's best friend. Richard Yelsits was the track welder beginning in 1958. He would have "Little Frankie" Ragen collect $1 from each driver as "welding insurance" in the event that welding was needed on a car after a rough night of racing. After Nazareth closed, Yelsits and Ragen started welding at Mahoning Valley Speedway. (Courtesy of Michelle Buttner.)

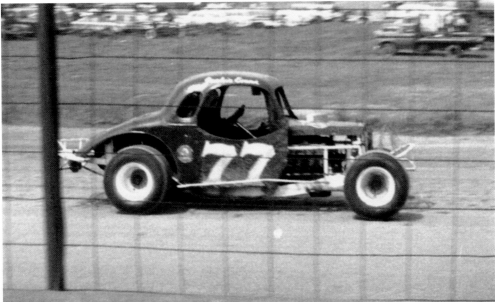

Jackie Evans races the No. 77 car on the one-mile track. A native of Miami, Evans was known as the "Miami Hurricane" and, by other drivers, as the "Great Dirt Thrower." He won two features at Nazareth and also raced at the Reading Fairgrounds, where he lost his life in 1970. (Courtesy of Jack Leach.)

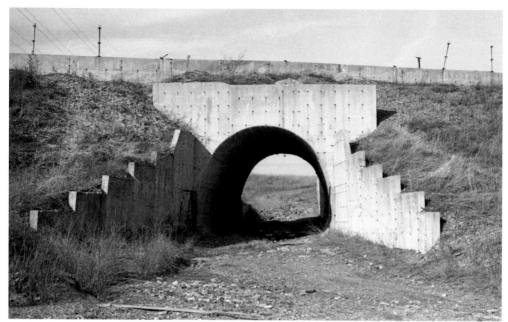

In the 1970s, the tunnel (above) was the only way to get into the infield, but it was starting to deteriorate and get overgrown with weeds. The "big" track stood vacant for more than 10 years until Lindy Vicari bought it, tore down some brush, and had a few races there starting in 1982. It later closed in 1984. The 1 1/8–mile track was then shortened to a one-mile track. The old track (below) still remained visible from the grandstands. It was paved a few years later after Roger Penske bought it. The only part of the old "big" track that still remains today is a wall along Georgetown Road. After that track was closed, the half-mile track still went strong with weekly racing events. The parking lot was adjacent to the big track. (Both, courtesy of Jack Kromer.)

THE DIRT TRACK YEARS

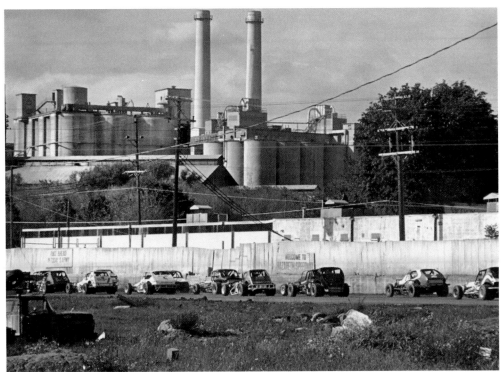

Cars go down the backstretch of the half-mile at Nazareth in 1978 with a cement plant in the background. Nazareth is also known for its cement industry, which has long been a global provider of cement products. Some say that cement dust that settled through the years made the track's dirt surface as hard as cement. (Courtesy of Jack Kromer.)

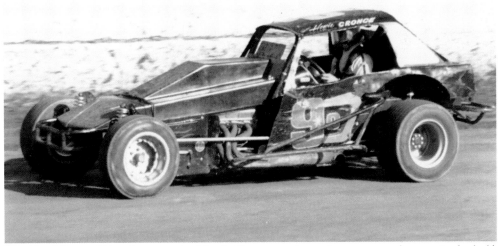

The No. 9C car of New Jersey native Howie Cronce navigates its way around a turn in the half-mile track. Cronce had a good year in 1977, visiting victory lane on three different occasions. He was known as "Howie the Hat" by fellow race car drivers. (Courtesy of Scott Peters.)

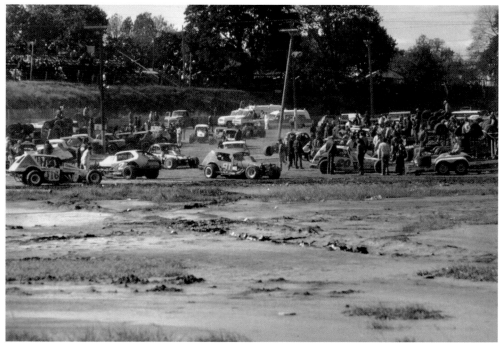

The pits are full of activity on the half-mile dirt track on this cool Sunday afternoon in October 1978. Frankie Schneider's No. 2 car, Buzzie Reutimann's No. 00 car, and Brett Hearn's No. 20 car are among the cars preparing for the race. The water trucks and emergency vehicles were also stationed in the infield. (Courtesy of Jack Kromer.)

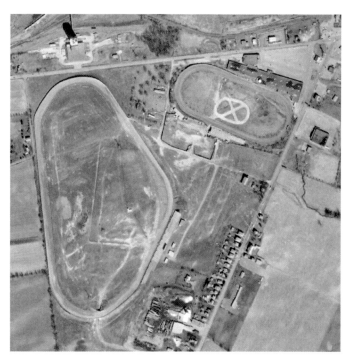

This 1971 aerial photograph shows both tracks and how they were configured. Route 248 runs across the top from east to west, and Route 191 is to the right, going from north to south. The half-mile track had figure-eight races on asphalt and demolition derbies on the front stretch. The "big" track was beside it. (Courtesy of Historic Aerials.)

THE DIRT TRACK YEARS

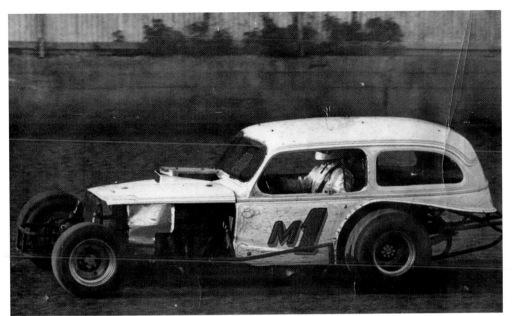

The No. M1 Sportsman car of Bobby Pickell is seen here on the dirt track. Pickell started his racing career with bicycles but later moved to cars, where he posted 36 wins at numerous tracks in his career, including 14 at Nazareth. (Bob Perran Racing photograph; courtesy of Jeff Berger.)

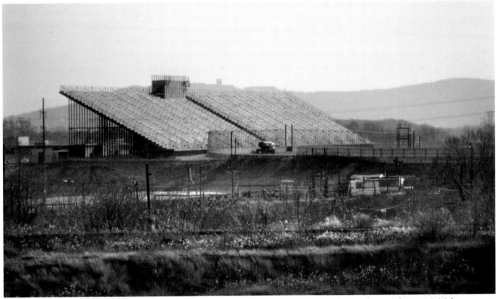

In addition to the half-mile track, Jerry Fried built the "big" 1 1/8–mile track in 1966 but went bankrupt in 1971. These new grandstands were erected at Nazareth after Lindy Vicari bought the track in 1982. In 1986, Roger Penske brought in temporary bleachers that were used until large, more colorful bleachers could be permanently installed. Those bleachers were then painted yellow and red, which could be seen for miles. Some other Penske-owned tracks have yellow and red bleachers as well. (Courtesy of Jack Kromer.)

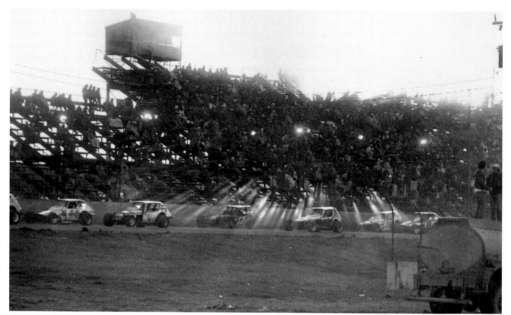

A race photographer captures the light as the sun goes down behind the bleachers and the half-mile dirt track. The drivers include Frank Cozze in the No. 44 car, Paul Rochelle in the No. 4 car, Carl Collis in the No. 12 car, Del Buss in the No. 4 car, Brett Hearn in the No. 20 car, and Bobby Pickell in the No. 300 car. (Courtesy of Jack Kromer.)

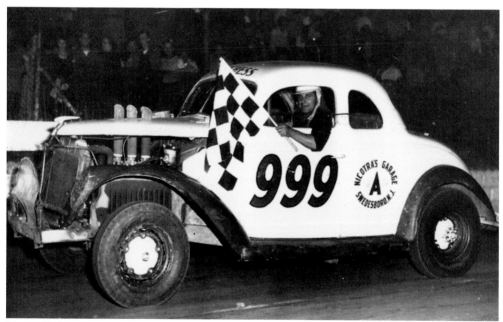

Howard "Otto" Harwi drove his No. 999 car to victory lane several times. He started out racing motorcycles at the age of 17 and took time off from racing during World War II to be a hard-hat diver. When he came back from the war, he took the car to five straight championship titles, from 1955 to 1959. (Courtesy of Harold Cope.)

Elton Hildreth (kneeling in front of the "12"), with his friends and crew members, poses for a photograph in the dirt track's infield. Long nights in the garage and at the track brought a lot of people together. Some drivers got their racing careers started at Nazareth and went on to larger racing careers in Indy Car, CART, and NASCAR. (Courtesy of Jeff Berger.)

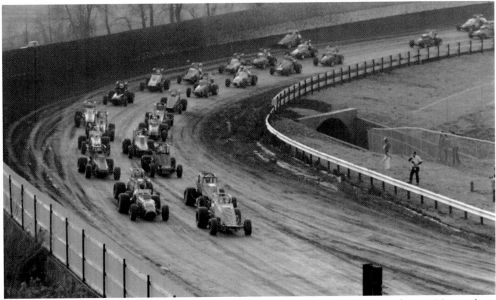

United States Auto Club (USAC) drivers get ready to go green out of turn four at Nazareth in 1982. USAC drivers tour the country, competing at numerous tracks. Some race for fun and others race for points. Although the dirt track was later replaced with asphalt, the tunnel still remains where it is seen here. (Courtesy of Scott Peters.)

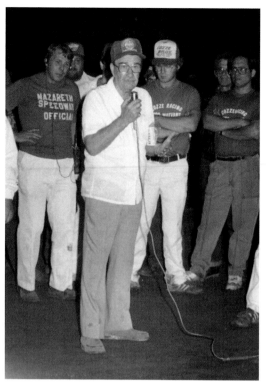

On August 31, 1988, after a long day and night of racing, longtime Nazareth promoter Jerry Fried talks to the crowd after the last stock-car race took place on the half-mile. There were tears from drivers, fans, and workers. The small dirt track days at Nazareth had come to an end. (Courtesy of Jack Kromer.)

After the end of the racing season in 1988, the bulldozers came and began tearing out the concrete from the half-mile dirt track. The half-mile track was removed to make room for Laneco Department Store (now Giant) and a strip mall. (Courtesy of Bob Snyder.)

THE DIRT TRACK YEARS

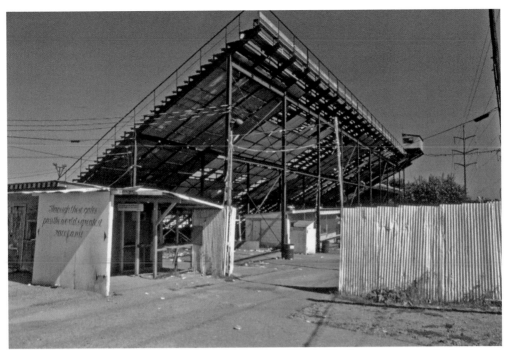

The main entrance is seen here after a night of racing. The half-mile entrance gate had a sign on the wall that read, "Through these gates pass the world's greatest race fans!" Concession stands and souvenir stands were under the bleachers. (Courtesy of Jack Kromer.)

A few weeks after the last checkered flag was waved on the half-mile dirt track in 1988, it was starting to come apart. Bleachers were coming down, walls were being taken apart, and the gates that so many great drivers went through were being dismantled. (Courtesy of Jack Kromer.)

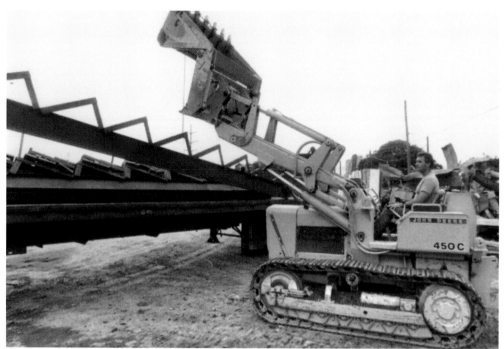

Race car driver Tighe Scott of Pen Argyl bought the old Nazareth half-mile grandstands at the track auction after the last race. He got a crew together quickly and started to take down the grandstands and put them on a trailer. Some were donated to his old high school, and some were given to another local track. (Courtesy of Jack Kromer.)

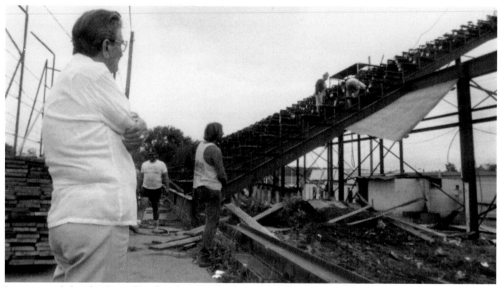

It was a sad day for Jerry Fried as he watched the bleachers come down in 1988. The track had been part of Fried's life for more than 35 years, and he was not ready to leave yet. An era was over, as short-track dirt racing came to an end in Nazareth. Fried passed away less than a year later. (Courtesy of Jack Kromer.)

THE DIRT TRACK YEARS

Thrills, Derbies,

and Enduros

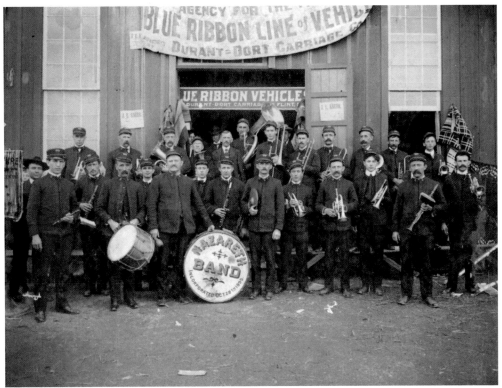

The Nazareth Band poses for a photograph outside the popular Fair House No. 1. The large band was incorporated in 1895 and played at the annual fair and at special events. They performed throughout the community and made appearances in local town parades a few times a year. (Courtesy of Darrell Mengel.)

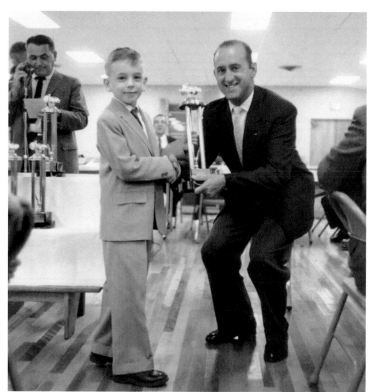

Eddy Sachs of Allentown gives a trophy to young Danny Keen at a banquet. Banquets were a time for drivers and crew members to put on a jacket and a tie, something different than their work clothes from the garage. Sachs had 65 career USAC and AAA starts, including one at the USAC Midwest Sprint Car Championship and eight at the Indianapolis 500. (Courtesy of Darrell Mengel.)

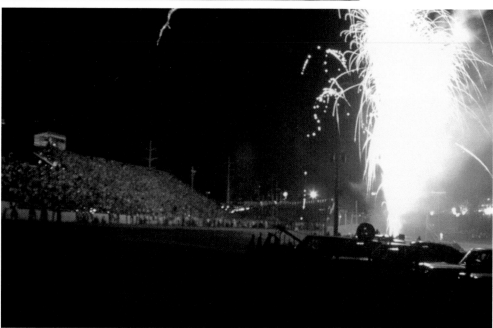

Fireworks always drew a large crowd when Jerry Fried put them on the racing schedule. The grandstands would be packed and cars would line up along the highway to see the fireworks, which went off from the infield. (Courtesy of Jack Kromer.)

THRILLS, DERBIES, AND ENDUROS

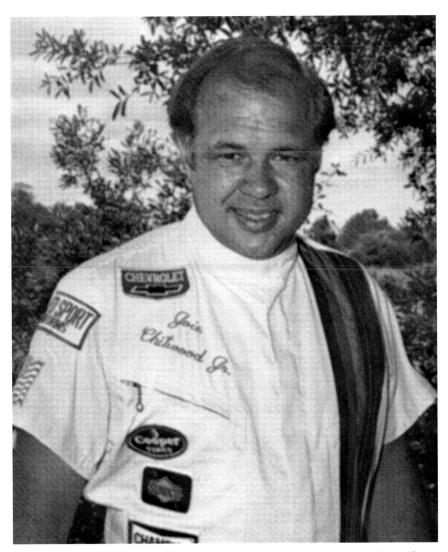

The Joie Chitwood Thrill Show performed at Nazareth on several occasions. Joie Chitwood Sr. was good friends with Jerry Fried, as they were both from nearby Reading, so it was only natural that Chitwood did a few shows at Nazareth. The exhibition of an auto-driving stunt show was so popular that there were eventually five separate units that traveled across North America performing at racetracks and fairgrounds for more than 45 years. Joie Chitwood Jr. (above) took over his father's business in 1965 along with his brother Tim. In 1997, Joie Jr. purchased an Indy Car to branch off briefly into auto racing. Tim and Joie III then ran the show for another year until Chevrolet canceled its sponsorship. They both continued to do stunt work for television and film. Joie Chitwood Jr. later worked for a friend's Chevrolet dealership before retiring, while Tim Chitwood still continues to perform about 25 shows a year with Chris Moreno, who does stunt work at Disney Studios in Florida. Joie Chitwood III is currently the president and general manager of Daytona International Speedway. (Tribune Photo Archives, courtesy of Tracy L. Berger-Carmen.)

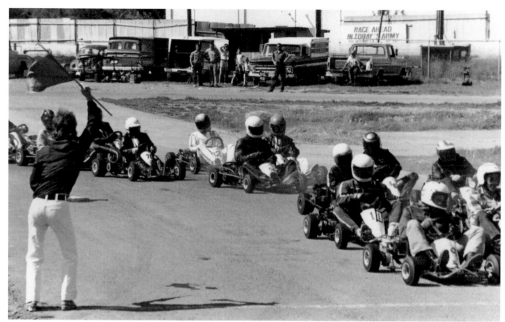

Go-cart races were held in the infield of the half-mile on a paved track in the middle of the oval. It was a popular event for youngsters, as there was always action going on. Some race car drivers started their careers racing go-carts at a young age. (Courtesy of Jack Kromer.)

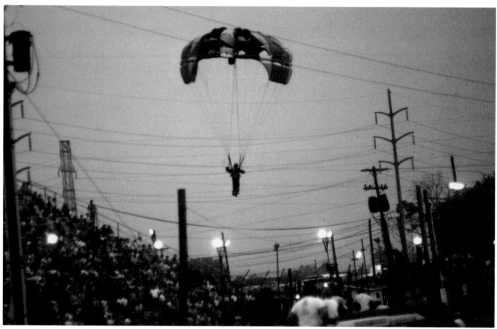

A skydiver lands in the infield, with the bleachers full of fans watching him land. On a few occasions, skydivers were brought in, and they always brought the crowds with them. It is unclear how they managed to navigate around the wires and the high-tension lines that ran through the infield. (Courtesy of Jack Kromer.)

Kids who watched the race on Easter Sunday got a really sweet treat: the chance to ride in one of their favorite race cars. Kids would run down from the stands and pile into a car for a loop around the track. They did not care how many kids were in a car, or even if they had a seat, since the driver was in it. Many drivers looked for their favorite fans in the stands to be sure that they got into their own car. There was also an annual Easter egg hunt in the infield. (Both, courtesy of George Maureka.)

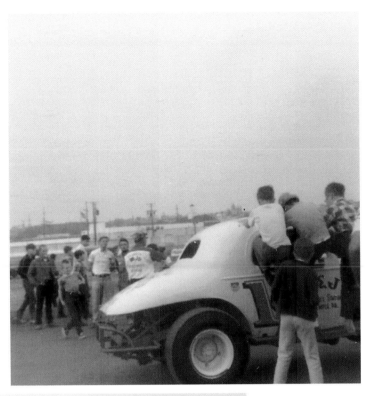

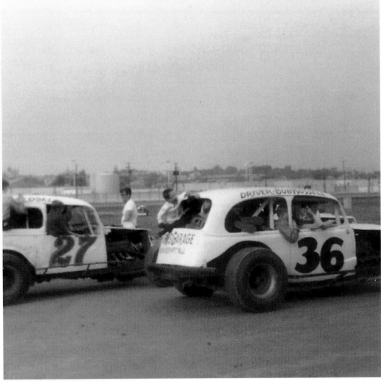

Herman's junkyard, down the street from the racetrack, is where the demolition derby car below, a 1958 Oldsmobile, was prepped and spray-painted with No. 146. The driver, Richard Berger Sr. of Bath, did not have a tow truck, so he drove the car to the track on the Lower Nazareth Township back roads. If it was drivable afterwards, it would be driven back again. If it was not, it would be left there for a tow truck to pick up the next morning. He ran one car in five different derbies until it was so badly mangled up that he had it crushed. Berger's son-in-law Larry Carmen went on to run in a few demolition derbies in 2004 and 2005 before racing enduros and factory stock cars at a few local tracks with his wife, Tracy Berger-Carmen. (Both, courtesy of Diana Berger.)

　　　　　　　　　　　THRILLS, DERBIES, AND ENDUROS

Hitting a car with the front end and getting a flat tire are not good when racing in an enduro, especially at Nazareth. With close to 200 cars on the track at once, it was hard just to get off the track towards the pits to get another tire or have someone in your pit crew hammer out your hood. (Courtesy of Joe Kunkel.)

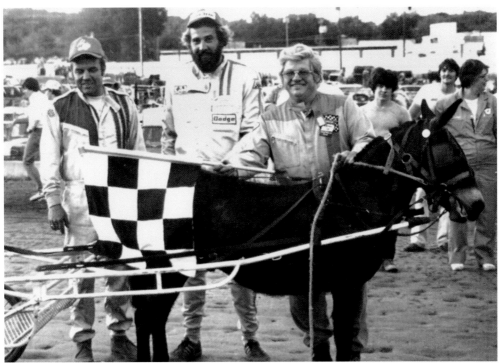

Donkey races were a very popular and entertaining event to watch at Nazareth. Here, from left to right, drivers Bobby Bottcher, Jack Zeiner, and Carl Van Horn got the checkered flag. Sulky carts were used for races in the early 1900s, pulled around the track by horses. Years later, carts were being pulled by donkeys and, sometimes, ostriches. (Courtesy of Bob Snyder.)

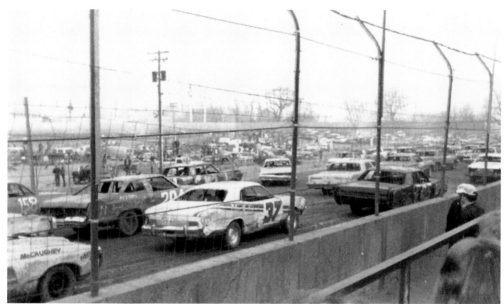

At the last enduro, in 1988, a total of 200 cars took the green flag. While some drivers had experience with this type of racing, others did not. Some drivers did not even realize that a racer does not win after the first lap. A steady car that stays out of trouble, avoids wrecks, and runs consistently on the track can do relatively well, however. (Courtesy of Phil Levering.)

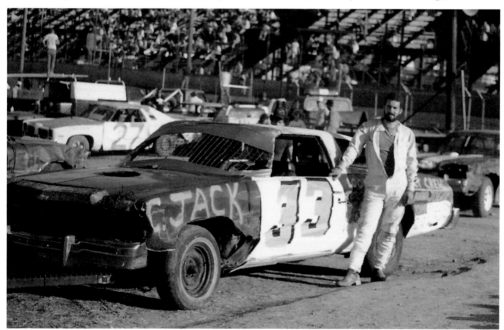

Driver Joe Kunkel of Alburtis poses next to his car, a 1973 Chevrolet Caprice. He raced four enduros at Nazareth and used this car in three of them. He drove with the Northeast Enduro Tour Series (NEETS) at Grandview Speedway from 2010 to 2012, finishing in the top 10 in points in all three seasons. (Courtesy of Joe Kunkel.)

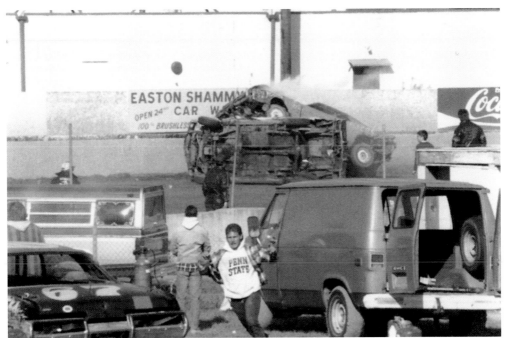

Enduro races provided non-stop entertainment for spectators watching from the grandstands. Cars would even go on top of one another, with the red flag rarely waved unless a driver was in trouble. The "dead" cars were left on the track as the live cars squeezed and scraped by them. (Courtesy of Joe Kunkel.)

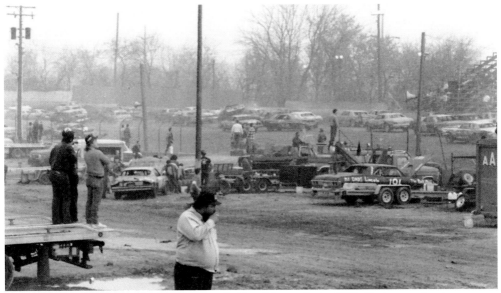

Cars battle it out during the final enduro held at Nazareth, in 1988. Enduro racing became an "overnight sensation" and exceeded Ward and Dot Crozier's expectations. Registration for the enduro division had to close after 200 entries were received, which occurred six weeks before the race was scheduled. (Courtesy of Penny Faust.)

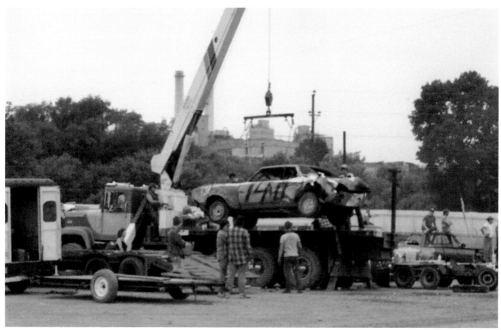

Nazareth Block Company, which was adjacent to the track, brings its big crane truck to the infield to help pick the cars off the track or put them back on a racing trailer to go home. They did this for a number of years to help out the track. (Courtesy of Penny Faust.)

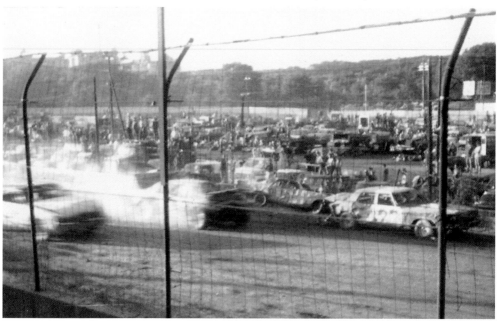

When a car overheats with this much smoke, it is usually a sign that it is done racing. Some drivers, however, might continue to stay out there until their car will no longer move. Others will try to make it into the infield pits to see if they can cool off the engine with water. (Courtesy of Phil Levering.)

THRILLS, DERBIES, AND ENDUROS

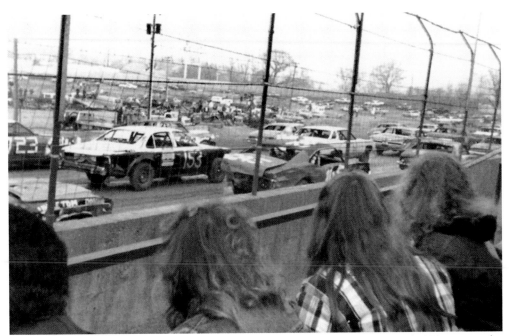

A group of spectators watches the last enduro race at Nazareth in 1988. With 200 cars on the track, there was always some kind of action to watch. Scoring was done by hand; in enduros, laps are counted. Today, most tracks have a transponder system. (Courtesy of Phil Levering.)

Cars get ready to take the green on the front stretch. With 200 cars on the track, it took a while to get all the cars in the right position to start the race. It was common for the last car in the lineup to be near the pace car. (Courtesy of Phil Levering.)

In the No. 25 car, Penny Faust of Trexlertown makes her way around the dirt track. She had a Buick Electra with a 455-horsepower motor. In the background, very close to the track, is the Laneco Department Store. Over the years, there was a slow increase in the number of women racing with men on the track. (Courtesy of Penny Faust.)

Mike Hirschman of Northampton captured the checkered flag during the final enduro ever to take place at Nazareth, in 1988, with his 1973 Chevrolet Impala. To this day, his helmet on his car has the original dirt and mud on it. He raced for a few years after Nazareth closed at various other tracks and did quite well. (Courtesy of Mike Hirschman.)

4

THE DAYS OF ASPHALT

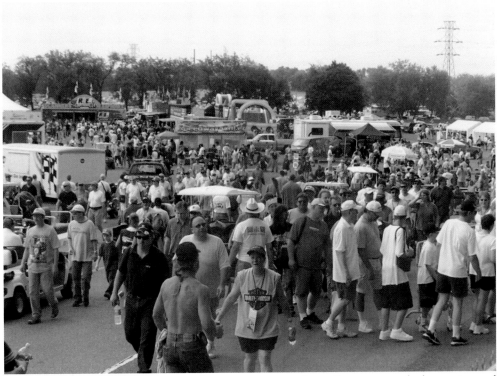

The midway at Nazareth Raceway is where numerous vendors sell team apparel, electronics, and souvenirs. They also had a stage for driver interviews, activities for children, cars on display, and concession stands. There was even an area where entrants could be timed on how fast they could change a race car tire. (Courtesy of Tracy L. Berger-Carmen.)

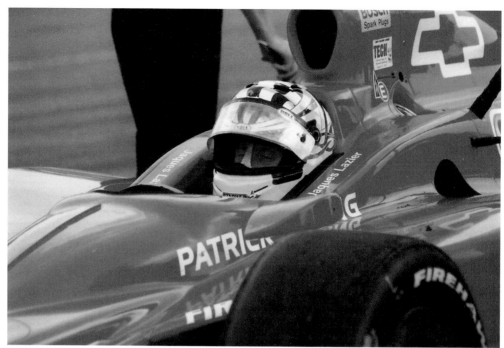

Jaques Lazier of the No. 20 car gets ready to leave the pits for a practice run at Nazareth. Lazier won the Indianapolis 500 in 1996 and continued to do well, finishing in the top 10 for the next six years in a row. His family members were familiar faces on the Indy 500 circuit as well. (Courtesy of Tracy L. Berger-Carmen.)

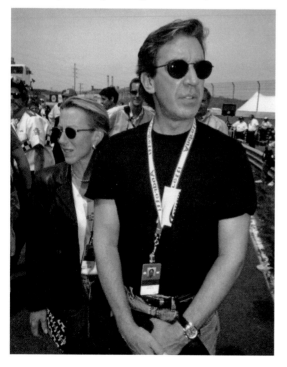

Tim Allen visited the asphalt track for a May 1997 race with his wife, Laura Diebel. While he was an actor on *Home Improvement*, he formed a race team called the Saleen/ Allen RRR Speedlab. He and Steve Saleen raced Ford Mustangs in the Sports Car Club of America (SCCA) World Challenge. (Courtesy of Jack Kromer.)

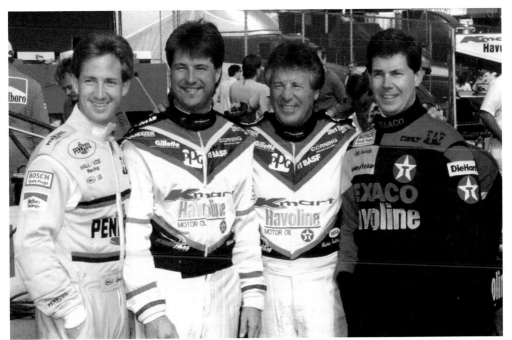

John, Michael, Mario, and Jeff Andretti pose for a photograph during a 1991 asphalt race. This specific race and the Indy 500 that same year were the only two occasions where all four of these Andrettis raced together. (Courtesy Bob Snyder.)

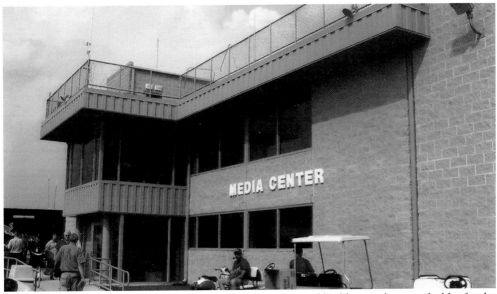

The media center at Nazareth Raceway was an air-conditioned building with rows of tables for the media to work on their stories, television monitors to watch the race live, and a public address system to accommodate driver interviews. Since it was adjacent to the pit area, the roof was available to watch and photograph the racing action. (Courtesy of Tracy L. Berger-Carmen.)

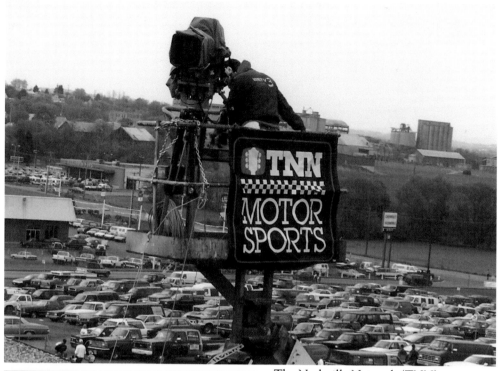

The Nashville Network (TNN) Motorsports broadcasted a few asphalt races on live television. Some camera operators were high in the sky to get the overall "establishing" shot of the track. They hired radio and television students from Northampton Community College in Bethlehem to be production assistants, giving them a wealth of knowledge in their future occupations. (Courtesy of Jeff Berger.)

Nevin George poses with his plaque after winning the Service Electric 100 NASCAR Modified Tour race at Nazareth in his No. 0 car. He was in the lead for 51 out of the 100 laps of the race. He had a few wins as well as top-10 finishes in his Modified Tour race career. (Courtesy of Scott Peters.)

THE DAYS OF ASPHALT

Zane Zeiner, from nearby Bath, grew up at the track, riding his bicycle around the pits while his dad and uncle raced figure-eight races and street stocks on the half-mile and one-mile dirt tracks. Years later, in 2002, with the family still building cars, his dream came true, as he raced on Nazareth's asphalt. (Courtesy of Scott Peters.)

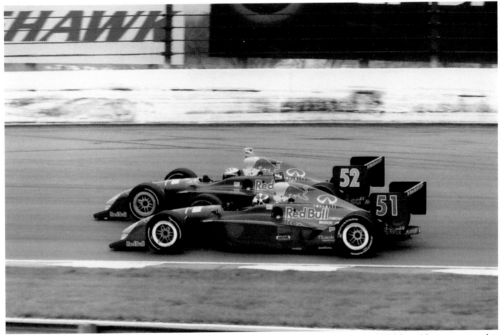

Red Bull sponsored drivers Thomas Scheckter, in the No. 51 car, and Eddie Cheever, in the No. 52 car. The teammates are seen here racing each other on Nazareth's asphalt. Cheever finished seventh in this Firestone Indy 225 race in August 2002, and Scheckter finished 21st after crashing his car. Both drivers have an impressive number of top-10 finishes in their careers. (Courtesy of Scott Peters.)

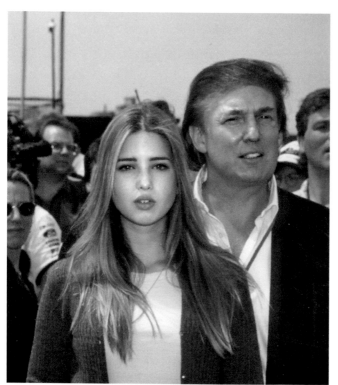

Seen here in the pit area during a May 1997 race are Donald Trump and his 16-year-old daughter Ivanka. Trump, well known from the television show *The Apprentice*, is the chairman and president of the Trump Organization and the founder of Trump Entertainment Resorts. (Courtesy of Jack Kromer.)

In 2002, Nevin George of Kunkeltown teamed up with Ralph Solhem and won his first Featherlite Modified (FLM) race on Nazareth's one-mile asphalt track in his No. 0 car. George was one of the youngest drivers on the tour and was named most improved driver that same year as well. (Courtesy of Scott Peters.)

THE DAYS OF ASPHALT

Roger Heffelfinger of Danielsville started racing when he was 16 years old, beginning with street stock cars on Nazareth's dirt track in the 1980s. Later, he drove Modifieds on the asphalt. What he liked best about Nazareth was that races were on Sundays and rarely competed with other track schedules. (Courtesy of Scott Peters.)

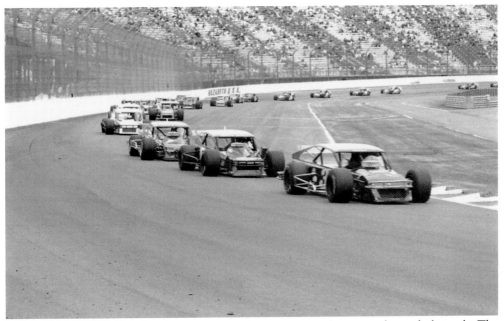

A string of Modifieds make their way around turns one and two on the asphalt track. The Whelen Modified Tour is a racing series operated by NASCAR that travels to numerous tracks around the country. It usually visits short-oval paved tracks but has also raced on larger ovals and even road courses. (Courtesy of Scott Peters.)

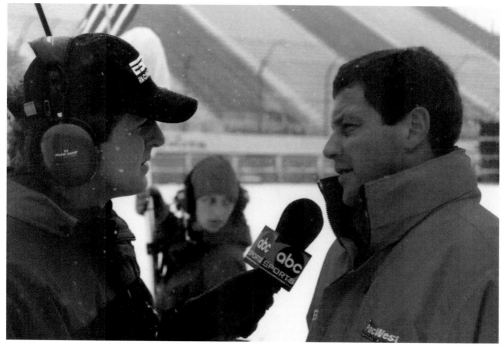

In May 2000, Nazareth made history when the Bosch Spark Plug Grand Prix became the first CART FedEx Championship Series event to be postponed by weather, in this case snow. The race was postponed for a few weeks. Since drivers could not race their cars, they played in the snow and talked to the media. Here, Mark Blondell is being interviewed by a television reporter. (Courtesy of Scott Peters.)

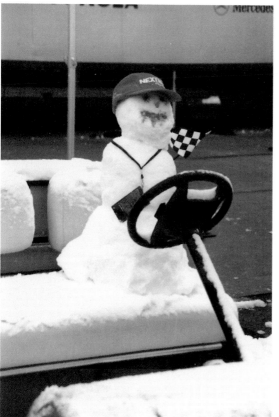

Since drivers and crew members could not do much with their cars when the snow came, they decided to have some fun in the snow, building this snowman and putting him behind the wheel of a golf cart. The snowman even had his own racing credentials. (Courtesy of Scott Peters.)

THE DAYS OF ASPHALT

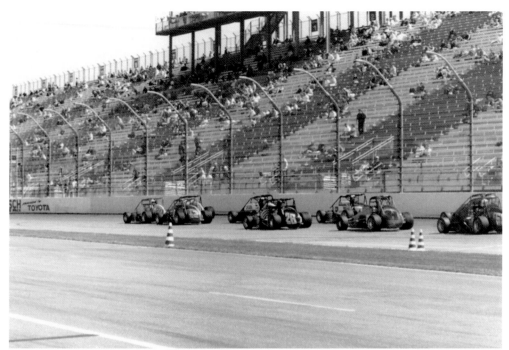

USAC champ cars race on the asphalt track on the front stretch. Many drivers in IRL and Sprint Cup Car Series started out racing these cars. (Courtesy of Scott Peters.)

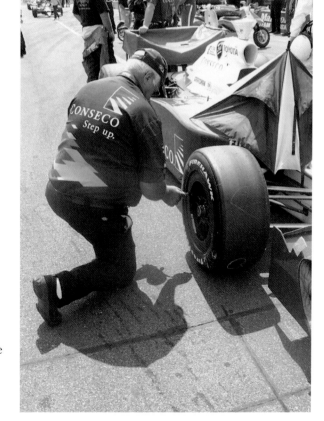

A member of the pit crew checks the tire pressure before this car goes out on the track. There is a science to tire pressure and how the car will wear down the tires while racing. On some teams, there is a dedicated person responsible for just the tires. (Courtesy of Tracy L. Berger-Carmen.)

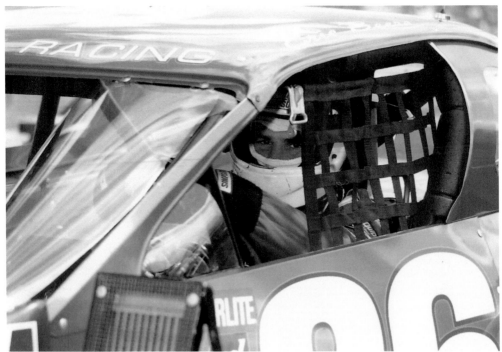

Local favorite Eric Beers, from Northampton, gets ready to race on the asphalt. He has been racing for more than 25 years and has won many features and championships at various tracks, along the East Coast. He currently races at Mahoning Valley Speedway on a regular basis. (Courtesy of Scott Peters.)

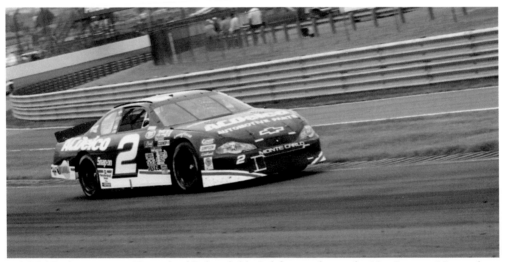

NASCAR driver Kevin Harvick of Bakersfield, California, drives the No. 2 car at Nazareth in 2001. As a child, he received a go-cart as a birthday present, which he used to earn seven national and two grand national championship titles before going on to Late Models while still in high school. After graduating high school, he went on to win numerous races and championships. (Courtesy of Scott Peters.)

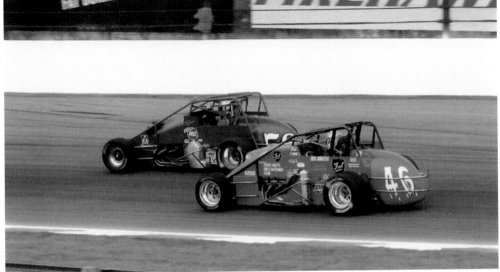

The USAC Silver Crown Series visited Nazareth Speedway. Here, Russ Gamester, in the No. 46 car, races against David Lee Darland, in the No. 56 car. Gamester, from Peru, Indiana, was the 1989 USAC National Midget champion. Darland, from Kokomo, Indiana, is only one of three drivers to earn three USAC championships. (Courtesy of Scott Peters.)

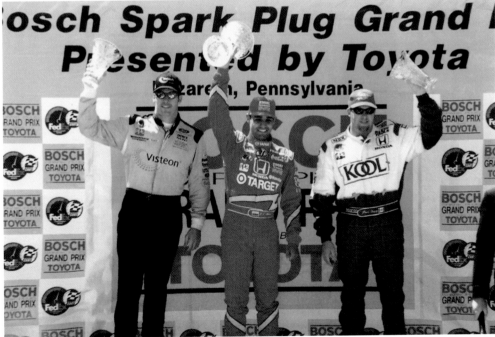

From left to right, P.J. Jones, Juan Pablo Montoya, and Paul Tracy pose for the media on the podium in victory lane at the Bosch Spark Plug Grand Prix race in May 2009. Montoya's No. 4 car led the race for 210 laps before winning the checkered flag. (Courtesy of Scott Peters.)

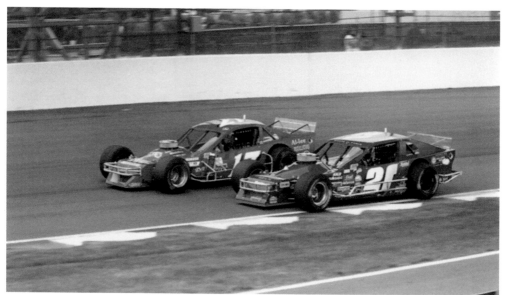

Mike Ewanitsko, in the No. 17 car, and Mike Stefanik, in the No. 21 car, battle it out for position on the one-mile asphalt. In the Service Electric 100 NASCAR Modified Tour race, Stefanik crashed and Ewanitsho went on to win the race. Ewanitsho raced for 10 years, and Stefanik continues to race and post impressive finishes. (Courtesy of Scott Peters.)

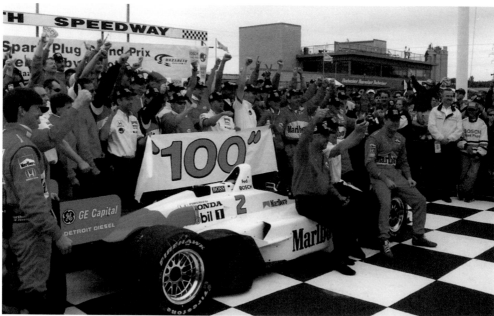

This photograph was taken after Gil de Ferran brought home a win at the Bosch Spark Plug Grand Prix in 2000. For owner Roger Penske, it was a historic 100th win that was celebrated with his crew in victory lane. The race was a makeup because it had snowed on the original race day, a few weeks earlier. It was a very close race, too, with de Ferran beating Mauricio Gugelmin to the checkered flag by only .815 seconds. (Courtesy of Scott Peters.)

Jason Keller of Greenville, South Carolina, celebrates in victory lane with a Busch beer bath. He started racing at a young age with go-carts before moving to Late Model Sportsmen when he was only 16. He is the first driver in history with over 500 career starts. (Courtesy of Scott Peters.)

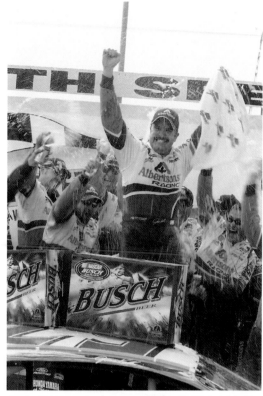

CART cars make their way around turns one and two in April 1988. The Air Products Bridge was one of two ways to get into the infield, the other being the tunnel in turns three and four. Route 248 is behind the bleachers, leading into the town of Nazareth. (Courtesy of Scott Peters.)

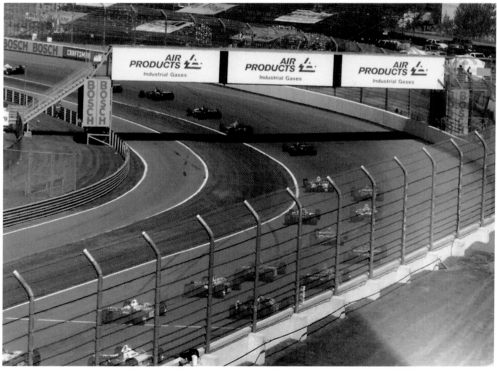

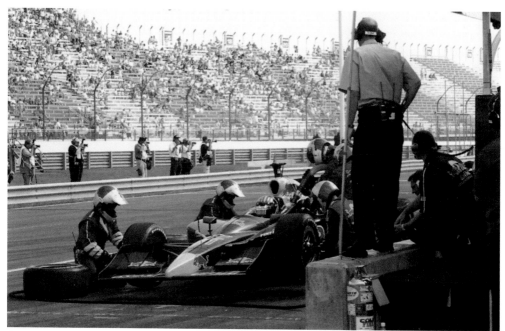

Driver Alex Barron stops his No. 51 car on pit road to get some new tires and more fuel. Pit crews practice for many hours to rehearse pit stops, since a few seconds can make the difference in a finish. (Courtesy of Tracy L. Berger-Carmen.)

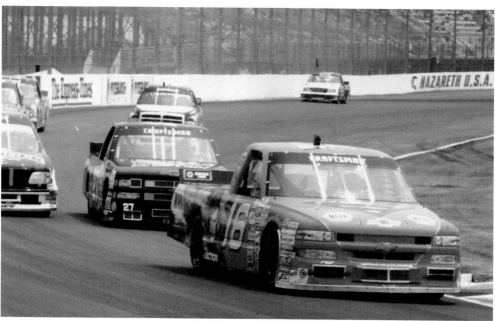

The Craftsman Truck Series (now the Camping World Truck Series) ran a few times on the Nazareth asphalt mile. This series is one of three NASCAR divisions that races modified pickup trucks. Driver Ron Hornaday Jr. of Palmdale, California, currently has the most wins in this series. (Courtesy of Scott Peters.)

THE DAYS OF ASPHALT

Sarah Fisher was a replacement driver at Nazareth. She is in the history books numerous times, including as the woman with the most starts (nine) in the 94-year history of the Indy 500, which she set in 2010. That same year, she wrote a book, *99 Things Women Wish They Knew Before Getting Behind the Wheel of their Dream Job.* (Courtesy of Scott Peters.)

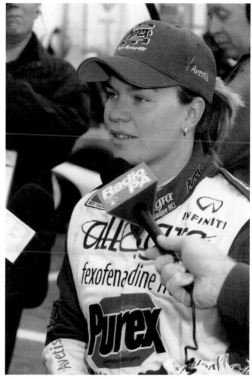

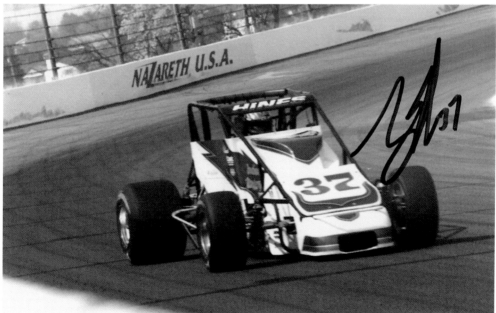

Tracy Hines of Newcastle, Indiana, drives the No. 37 car on asphalt. He started racing in the early 1990s and has three national wins at Nazareth. Currently, he has 85 overall national wins, as well as a few championships. In 2004, Hines won the last Sprint Cup race at Nazareth before the track closed. (Courtesy of Scott Peters.)

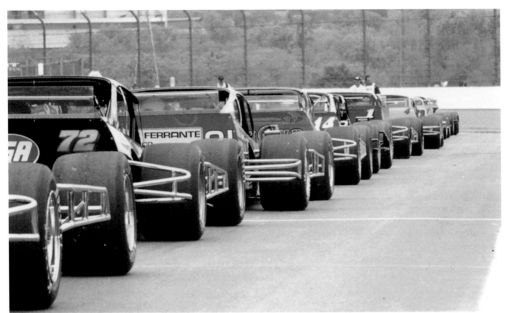

The NASCAR Featherlite Modifieds line up in a row to start a race in 2001. The division is currently called the NASCAR Whelen Modified Tour and is one of the oldest divisions in NASCAR, having started in Daytona Beach, Florida, in 1948 as the first NASCAR-sanctioned event. (Courtesy of Scott Peters.)

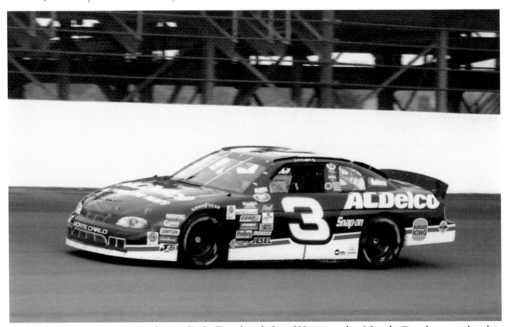

A third-generation race car driver, Dale Earnhardt Jr. of Kannapolis, North Carolina, makes his appearance at Nazareth. He is one of the most popular drivers on any given track and has been named NASCAR's most popular driver 10 times in a row. Currently, he has 19 career victories, including one at the Daytona 500. (Courtesy of Scott Peters.)

Firestone 225 winner Scott Sharp, of Norwalk, Connecticut, holds his trophy high as he celebrates in victory lane on April 21, 2002. He started the race in 11th place and moved up to lead the last 33 laps en route to the checkered flag. His Dallara IR0/Chevrolet No. 8 continues to perform well. (Courtesy of Scott Peters.)

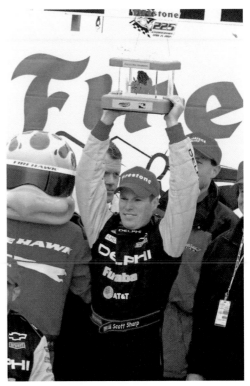

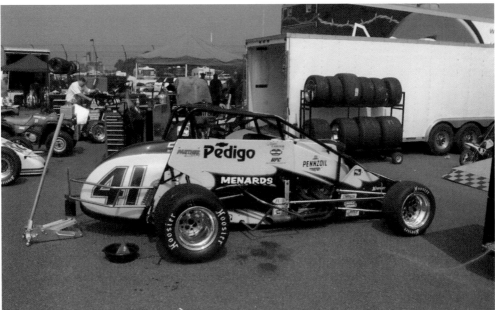

Drivers usually spend more time in the pits than actually driving on the track. A lot of preparation needs to take place before a driver can get into the car and take the green. This No. 41 car is driven by third-generation race car driver Dane Carter of Brownsburg, Indiana. (Courtesy of Tracy L. Berger-Carmen.)

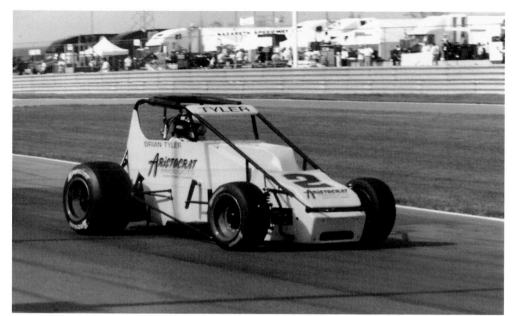

Brian Tyler of Albion, Michigan, races his No. 2 car on the asphalt. In 1996 and 1997, he won the USAC National Sprint Car championship for Larry Contos Racing. He has also raced in the NASCAR Busch Series, the NASCAR Craftsman Truck Series, the Indy Racing League (IRL), and the Automobile Racing Club of America (ARCA). (Courtesy of Scott Peters.)

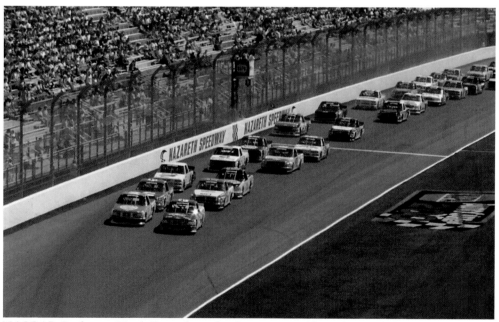

NASCAR Craftsman Truck Series (now the Camping World Truck Series) drivers put the pedal to the metal for 200 laps during the NAPA Auto Care 200 truck race in July 1998. There were 10 caution flags used in the 37 laps of the race. Ron Hornaday Jr. won that day in a Dale Earnhardt–owned Chevrolet Silverado. (Courtesy of Scott Peters.)

THE DAYS OF ASPHALT

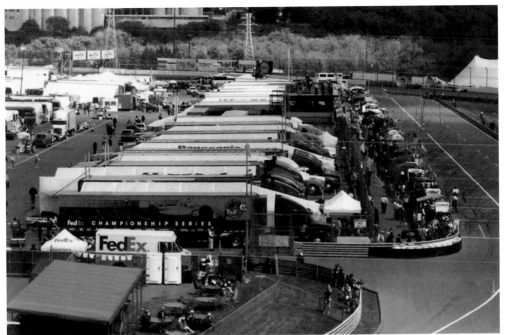

A sea of race haulers occupy pit road during the Bosch Spark Plug Grand Prix Cart Indy race in April 1998. Jimmy Vasser won $100,000 for taking the checkered flag that day. His No. 12 Reynard 98i/Honda car led for 41 laps of the race, which featured seven caution flags. (Courtesy of Scott Peters.)

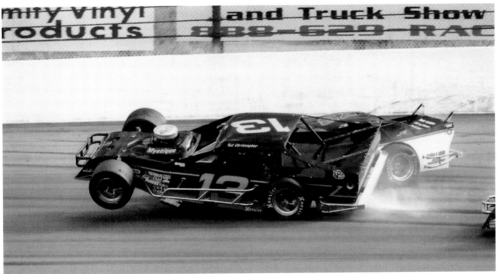

Ted Christopher of Plainville, Connecticut, in the No. 13 car, lifted three of his wheels up and over the No. 23 car along the front stretch. Christopher has a lot of racing experience, having competed in NASCAR's Sprint Cup, Nationwide Series, Craftsman Truck Series, and Whelen Modified Tour, as well as in Late Models, Pro Stocks, Midgets, and Supermodifieds. (Courtesy of Scott Peters.)

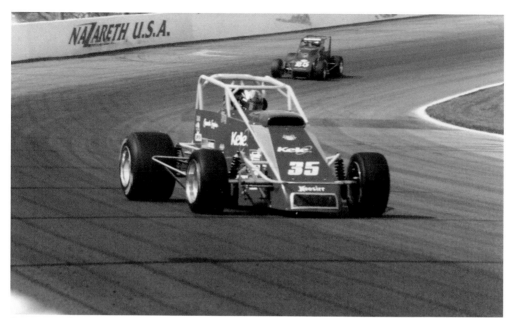

Sprint car driver Dan Drinan, in the No. 35 car, races on the asphalt during a 2002 race on the one-mile track. He had bad luck qualifying for the Indianapolis 500, where he failed to qualify three times due to crashes or equipment failures. However, he was successful in USAC Sprint car and Midget racing. (Courtesy of Scott Peters.)

Michael Roselli Jr. of Pocono Heights races his No. 198 car on the asphalt during the Bully Hill Vineyards 100 in the USAC Weld Racing Silver Crown Series. His car was sponsored by Weiland Racing Products and featured a Beast chassis and a Brannan Chevrolet engine. He only completed 65 laps of the race and had to go to pit road after having problems with handling. He eventually finished in 26th place. (Courtesy of Tracy L. Berger-Carmen.)

　　　　　　　　THE DAYS OF ASPHALT

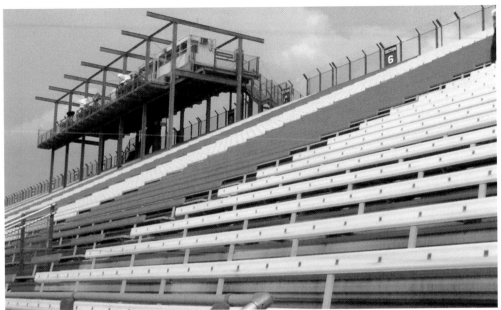

The yellow and red aluminum bleachers with backrests for added comfort could accommodate 46,000 fans at Nazareth Speedway. The bleachers added to the Nazareth skyline and could be seen for miles. After the last race at Nazareth, the bleachers were disassembled, transported, and erected at Watkins Glenn International in upstate New York. (Courtesy of Tracy L. Berger-Carmen.)

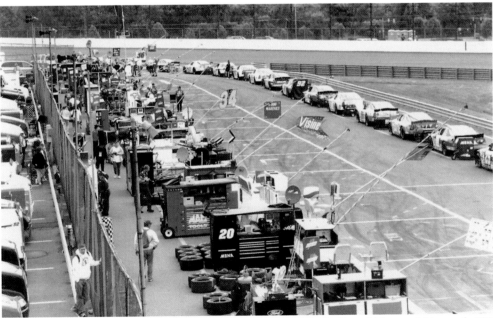

The pit stations and cars are lined up for the NASCAR Busch Grand National Nazareth 200 race. In the foreground, tires are laid out to be taken at a moment's notice. The seats on top of the pit stations are for the spotters to communicate with the driver if there are any problems, cautions, or accidents on the track. (Courtesy of Scott Peters.)

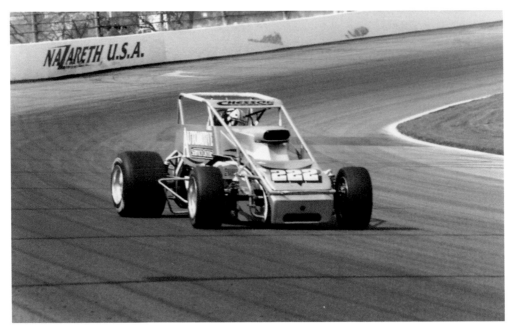

James Chesson of Far Hills, New Jersey, comes out of turn two in his No. 222 car. He was a Sprint Car driver and was in the World of Outlaws STP Sprint Car Series. He joined his brother P.J. three times in the Indy Pro Series in 2004, finishing 14th in points. (Courtesy of Scott Peters.)

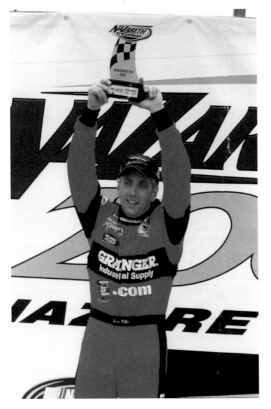

Nazareth 200 winner Greg Biffle of Vancouver, Washington, celebrates in victory lane after getting the checkered flag in the NASCAR Busch Grand National race in July 2001. His No. 60 JR-B63/Ford car, owned by Jack Roush, owned the lead for 85 laps. Currently, he has 18 wins and 2 championships in his career. (Courtesy of Scott Peters.)

THE DAYS OF ASPHALT

Racing trailers are parked side-by-side in the pit area. This is where the drivers usually stay before a race. Before some races, a convoy of trailers would parade through town before going to the track, with people lining the streets to have a look. (Courtesy of Tracy L. Berger-Carmen.)

Mornings start early at the track, especially on race day. Here, spectators begin to trickle into the stands as drivers and crew members do routine preparations to get ready to go green. Concession stands open early to sell breakfast and coffee to help them start the long day ahead. (Courtesy of Tracy L. Berger-Carmen.)

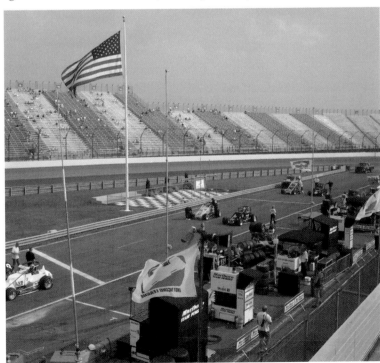

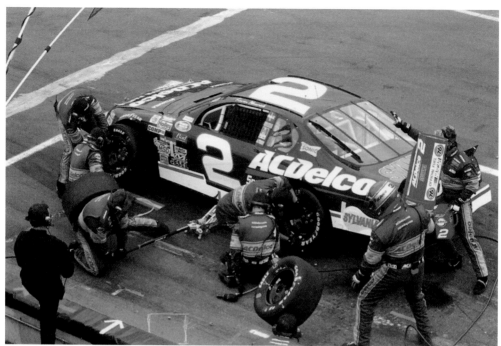

Kevin Harvick gets a new set of wheels during a pit stop at Nazareth. His crew works fast to get him back out on the track again. Although he led for the most laps (90), he came in second behind Greg Biffle that day, at the NASCAR Busch Grand National Nazareth 200 in July 2001. (Courtesy of Scott Peters.)

Although it was quite a hike to get to the top of the bleachers, it was well worth it to see the spectacular view of the racing action on the one-mile track. A year after this photograph was taken, these stands were dismantled and taken to another track, where they still remain yellow and red. (Courtesy of Tracy L. Berger-Carmen.)

THE DAYS OF ASPHALT

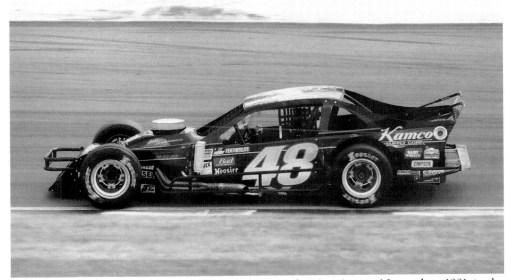

Tony Hirschmann of Northampton made his debut in the No. 48 car at Nazareth in 1991, in the Busch Grand Series. In the May 2002 Service Electric 100, he started fifth and finished third. He won one race at Nazareth and has won numerous races and championships at other tracks. (Courtesy of Scott Peters.)

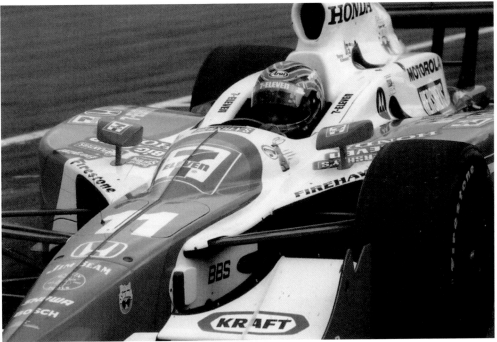

Antoine Rizkallah Kanaan Filho, known to most fans as Tony Kanaan, is seen here in the No. 11 car. He is preparing to race as his pit crew assists him before going out on the track. Kanaan, in the 7-Eleven sponsored car, went on to win the 2004 Indy Racing League Indy Car Series championship. (Courtesy of Tracy L. Berger-Carmen.)

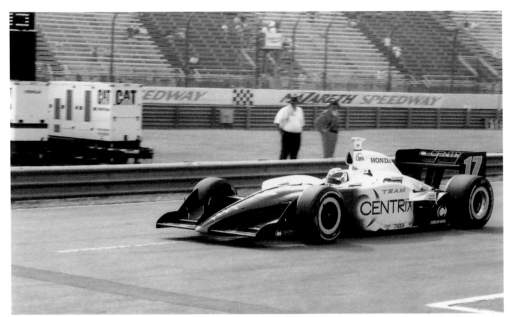

Vítor Meira of Brasília, Brazil, is seen here in the No. 17 car, driving onto pit road after an early-morning practice session. The Bobby Rahal–owned Panoz GF09/Honda car has twice recorded a second-place finish at the Indianapolis 500. Meira also has many top-10 finishes in his racing career. (Courtesy of Tracy L. Berger-Carmen.)

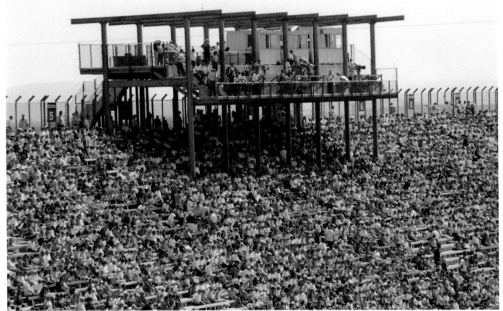

The grandstands at Nazareth were able to hold 46,000 spectators. Two-thirds of the grandstands were full, but only for the last race that took place there. Ticket prices went up when the asphalt track opened, with some fans having to spend $60–$80 per ticket. When the half-mile dirt track was there, tickets were usually under $10. (Courtesy of Tracy L. Berger-Carmen.)

THE DAYS OF ASPHALT

5

THE LAST
CHECKERED FLAG

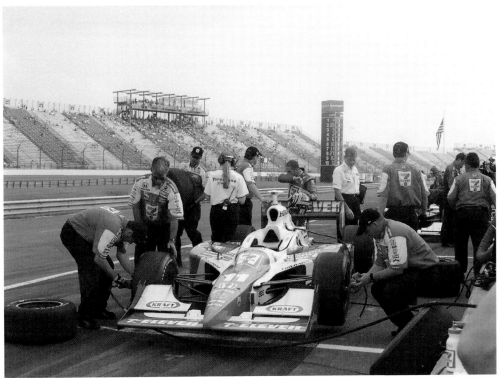

Crews and officials work on Tony Kanaan's No. 11 car on pit road in precaution for a practice session before the Firestone Indy 225 race. (Courtesy of Tracy L. Berger-Carmen.)

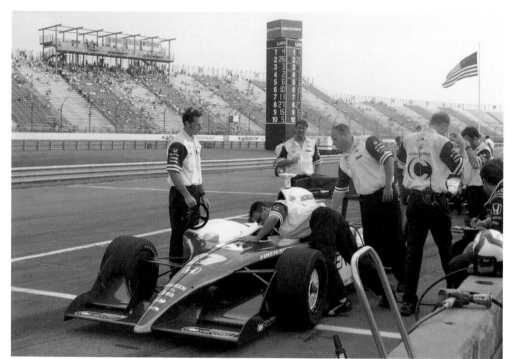

Vítor Meira's pit crew works on his No. 17 car. His Panoz GF09/Honda car finished 10th at the Firestone Indy 225. Meira was a CSAI Formula 3000 driver in Italy before he raced IRL. His last race in the IRL series was in 2011. (Courtesy of Tracy L. Berger-Carmen.)

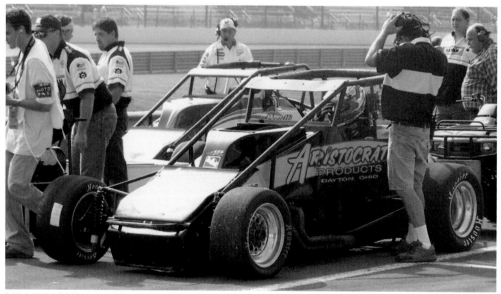

USAC Weld Racing Silver Crown Series cars get ready to go out for a practice run. Crew members are doing last-minute adjustments and making sure that their drivers are set to go. This was an early-morning practice, as people are first starting to arrive and make their way to the stands. (Courtesy of Tracy L. Berger-Carmen.)

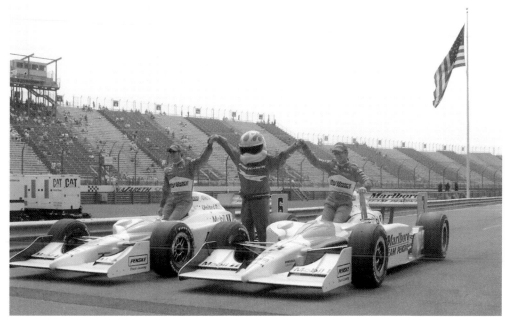

Sam Hornish Jr. (left), in the No. 6 car, holds hands with the Firehawk mascot, who is holding hands with Hornish's teammate Helio Castroneves, in the No. 3 car. These were the only two drivers that Roger Penske had in the Firestone Indy 225. (Courtesy of Tracy L. Berger-Carmen.)

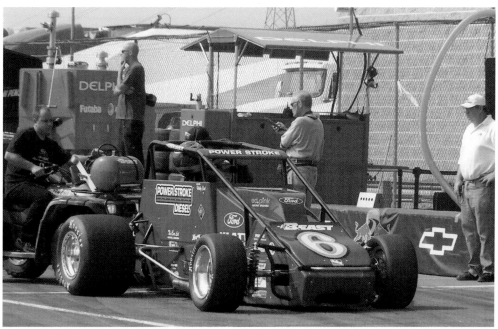

Bobby East of Brownsburg, Indiana, in the No. 6 car, waits to get "push started" onto the track to start racing. These specific cars need a four-wheel-drive vehicle, either driven by a crew member or a volunteer, to push the car until the car's engine is able to fire up. (Courtesy of Tracy L. Berger-Carmen.)

NAZARETH SPEEDWAY

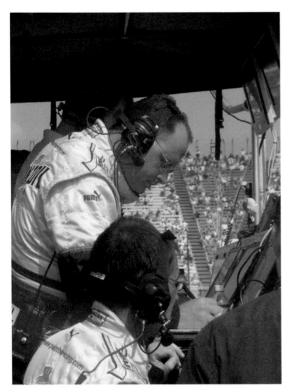

Crew members work together in the pits at their stations, evaluating the race. Racing comes down to a science since one must calculate everything from the tire pressure to the track to the air temperature to amount of fuel being used. If any numbers are off, it may indicate a problem. (Courtesy of Tracy L. Berger-Carmen.)

In any type of racing or motorsports event, there is a lot of waiting until the green flag drops. Here, drivers at the Indy 225 race at Nazareth hang out on pit road with their fellow drivers, teammates, and significant others as they wait to have their pictures taken. (Courtesy of Tracy L. Berger-Carmen.)

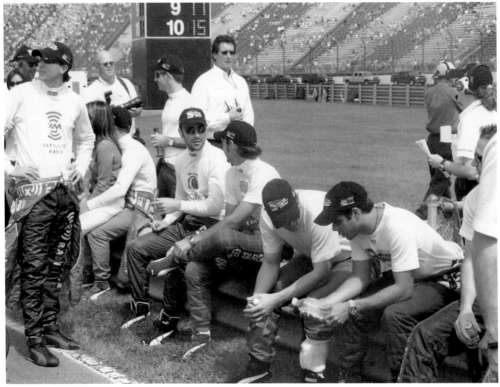

THE LAST CHECKERED FLAG

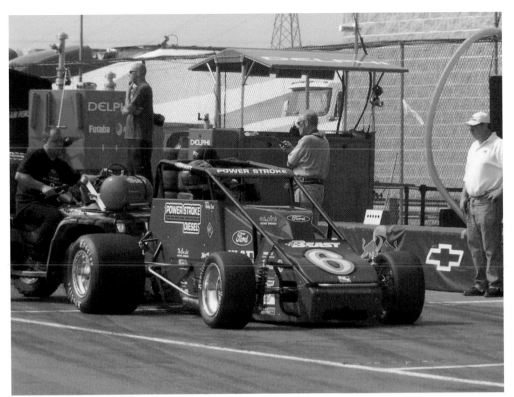

Crew members are behind the wall in a makeshift garage, working on another engine. In some series, it is common to have extra parts, like an engine or even a whole car, to replace anything that malfunctions or breaks. If something happens during practice or early in a race, replacements can be used. (Courtesy of Tracy L. Berger-Carmen.)

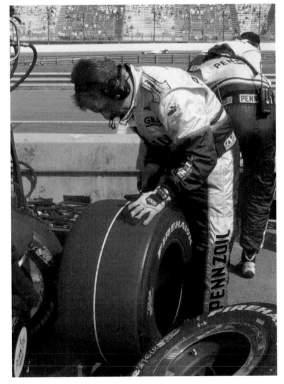

A crew member is seen here measuring tires for stagger. A crew member can learn a lot of information from looking at a used tire, including how and where it is wearing. (Courtesy of Tracy L. Berger-Carmen.)

Drivers in the Firestone Indy 225 race at Nazareth Raceway pose for the cameras and the media in one of the last group photographs taken at the track. Moments later, the area was transformed into victory lane for race winner Dan Wheldon. (Courtesy of Tracy L. Berger-Carmen.)

Tracy Hines celebrates a victory with his family, friends, and crew. His car, sponsored by Team Mopar-Penray and featuring a Beast chassis and a Mopar engine, made it to the checkered flag first in the last USAC Silver Crown Series race held at Nazareth Speedway, in August 2004. (Courtesy of Tracy L. Berger-Carmen.)

Helio Castroneves poses for the media after receiving his trophy for getting the pole position for the Firestone Indy 225 race at Nazareth. Castroneves stated that the car's handling was a problem at the end, but he still managed to finish fifth. (Courtesy of Tracy L. Berger-Carmen.)

Crew members work on the No. 5 car of José Adrián Fernández Mier of Mexico City. He retired from CART/IRL racing in 2004, drove for two years in the NASCAR Busch Series, and is currently racing in the American Le Mans Series (AMLS) LMP2 class for the Acura factory team. (Courtesy of Tracy L. Berger-Carmen.)

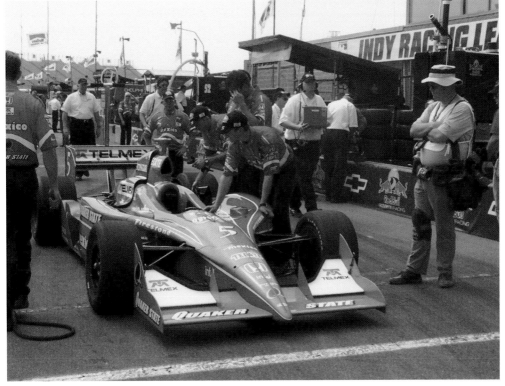

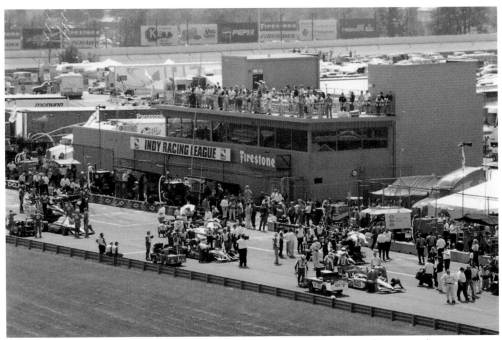

Drivers and crew work on pit road moments after the pre-race festivities have ended, doing last-minute preparations. Later, after the national anthem was sung, the most famous words in racing, "Gentlemen, start your engines," were heard, and the last race was under way. (Courtesy of Tracy L. Berger-Carmen.)

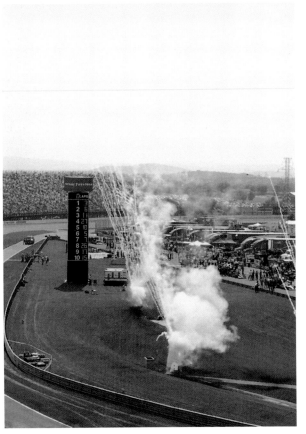

Daytime fireworks shot into the sky from the infield near pit road as the last race at Nazareth, the Firestone Indy 225, was brought to an end. Many people watching the race had already made their way to the parking lot in hopes of getting out before the traffic became congested. (Courtesy of Tracy L. Berger-Carmen.)

THE LAST CHECKERED FLAG

Cars take the green for the last race ever at Nazareth Speedway. The Firestone Indy 225 went down in the history books, as there were four caution flags totaling 42 laps. (Courtesy of Tracy L. Berger-Carmen.)

Tracy Hines is going across the finish line as the last checkered flag is waved. It was very close up to the end. But Hines was a fraction of a second faster. He took a final victory lap and drove his car to victory lane for pictures. (Courtesy of Tracy L. Berger-Carmen.)

Nazareth native Michael Andretti is all smiles as he walks down pit road to victory lane. It was a storybook ending for Nazareth Raceway, as Andretti's team won a "Triple Trifecta," as the *Express-Times*, a local newspaper put it, with his three drivers finishing first, second, and third in the last race ever held at Nazareth Raceway. (Courtesy of Tracy L. Berger-Carmen.)

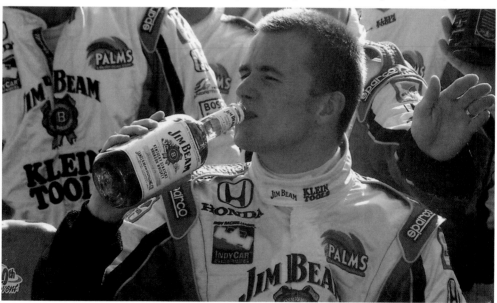

British native Dan Wheldon, the driver of the No. 26 car in Victory Lane, enjoys a much-needed beverage after winning the Firestone Indy 225 at Nazareth Speedway on August 29, 2004. Wheldon won the Indianapolis 500 twice as well as the IRL Series Championship in 2005. Sadly, he lost his life in 2011 at Las Vegas Motor Speedway while doing something he loved: racing. (Courtesy of Tracy L. Berger-Carmen.)

THE END

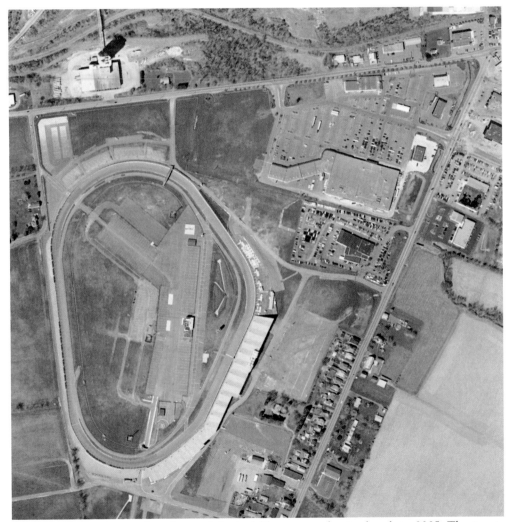

This aerial view shows what the track looked like a year after it closed, in 2005. The iconic bleachers were removed shortly after this photograph was taken. Route 248 runs across the top from east to west, and Route 191 is to the right, going north to south. (Courtesy of Historic Aerials.)

These photographs show the track in April 2013. There is now a deserted feeling in the air, as the place where cars zoomed around the track and fans cheered in the grandstands stands motionless, as if time stood still. The media center (above) was the central hub for not only the media but for drivers as well. The windows are now broken. On the inside, there are smashed ceiling tiles, telephones that have been thrown around, and glass everywhere, from vandals that have broken in. The infield care center is in similar condition, with stretchers thrown outside exposed to the elements. On the inside, medical supplies have been thrown around and furniture is knocked over. Below, the acceleration lane on the front stretch towards turn one is starting to get consumed by potholes and overgrown weeds. (Both, courtesy of Scott Peters.)

THE END

Along the backstretch (above), trees and weeds are growing from years of neglect. There were six cuts made by a backhoe into the track to prevent cars from driving on the asphalt. Weeds and even trees are now growing in the middle of the track from the uprooted ground. Some trees have fallen over onto the track, while nuts and bolts are scattered from the removal of the infield guardrails. In victory lane (below), the Nazareth Speedway sign has been weathered and broken up. Panels of the checkered flag are getting weeds in between their faded tiles and a garbage can sits upright, frozen in time. (Both, courtesy of Scott Peters.)

Discover Thousands of Local History Books
Featuring Millions of Vintage Images

Arcadia Publishing, the leading local history publisher in the United States, is committed to making history accessible and meaningful through publishing books that celebrate and preserve the heritage of America's people and places.

Find more books like this at
www.arcadiapublishing.com

Search for your hometown history, your old stomping grounds, and even your favorite sports team.